The
CALLIGRAPHY
SOURCE BOOK

The essential reference for all calligraphers.

The
CALLIGRAPHY
SOURCE BOOK

The essential reference for all calligraphers.

Compiled by Miriam Stribley

RUNNING PRESS
PHILADELPHIA, PENNSYLVANIA

A QUARTO BOOK

Library of Congress Cataloging in Publication Data
Stribley, Miriam
 The calligraphy source book.
 Includes index
 1. Calligraphy-copy-books. 2. Alphabets.
 I. Title.
Z43.C186 1986 745.6'1 86-10190
ISBN 0-89471-468-6

Running Press Book Publishers,
125 South Twenty-Second Street,
Philadelphia, Pennsylvania 19103.
This book can be ordered by mail from the publishers.
Please include $1.75 for postage. **But try your bookstore first.**
Toll-free order number 1-800-428-1111

This book was designed and produced by
Quarto Publishing Ltd
The Old Brewery, 6 Blundell Street, London N7 9BH

Art Director Alastair Campbell
Editor Carolyn King
Art Editor Moira Clinch
Designer Tom Deas

Editoral Director Jim Miles

Photographer Paul Forrester

Manufactured in Hong Kong by
Regent Publishing Services Limited
Printed by Leefung Asco Printers Limited,
Hong Kong

The publishers would like to thank Mick Hill and
Ursula Dawson. Special thanks must be extended to
Judy Martin for her major contribution to this book.

CONTENTS

INTRODUCTION

Whereas handwriting is a convenient skill, calligraphy is a craft of deliberation and invention. The emphasis on consistency and excellence of form in calligraphy distinguishes it from ordinary handwriting, even when that is both elegant and functional. But it is the fluid quality of pen or brush writing that marks out a calligraphic form from constructed or mechanical styles of lettering, and these distinctions are the essence of the way calligraphy is studied and practiced.

To copy and repeat a particular letterform until the execution of the writing is perfected is not a prescription for uniformity, with every calligrapher learning only to reproduce the model hands. It is one of the particular pleasures of calligraphy that the unique style and touch of the scribe affects the descriptive qualities of the writing, even when the source is a well-established traditional form. The personal style of a highly skilled calligrapher is stamped upon the work as clearly as a signature.

Modern calligraphy, like other arts and crafts, is informed by the history and development of the discipline, but also alive to contemporary standards of design. The style of modern letterforms may be derived from any of a number of influences, past or present and is also responsive to the range of tools and materials available to the calligrapher, which is currently more varied and imaginative than ever before. The investigation of beautiful writing samples and repeated practice of their typical features is a means of establishing sound technique and a spur to the invention of new variations.

The development of written forms

The Roman alphabet, the system of written communication common to the languages of the Western world, is an extremely economical and sophisticated resource. Of the 26 letters of its standard form, 23 were in use during the period of the Roman Empire. They had been preceded over many centuries in different civilizations by the use first of pictorial symbols standing for words and concepts, then by abstract derivations from these characters which retained or adapted their basic meanings and subsequently were converted to symbols relating to sound. The Roman alphabet, adapted from the Greek, produced the most systematic and versatile means of recording language and, due to the widespread power and influence of the Empire, became the standard element of written form throughout western Europe.

The economy of this alphabet system lies in being able to construct such a great variety of syllabic combinations from the restricted number of symbols. The letter **A**, for example, can be used to convey seven different sound values, while **I** has some 23 phonetic valuations. With the peak and decline of the Roman Empire, the development of writing lay entirely within this framework, although during the medieval period three additional letterforms – **J, U** and **W** – were inserted to distinguish certain sounds previously related to the letters **I** and **V**.

The classical form of Roman lettering is beautifully recorded in many surviving monumental inscriptions in stone. As befits its social and political function, this is the most stately and sophisticated expression of the basic alphabet letters. Importantly, too, it is clear that the character of the lettering derives not only from abstract properties of design, but from the very practical considerations which arise from the actual process of carving in stone. For less formal styles of writing, the regular proportions of the squared capitals were adapted to the more compressed, fluid forms known as Rustic capitals, and a rapid cursive hand developed in day-to-day business and administration which is not readily legible to modern eyes.

Documents and manuscripts were written on papyrus, using reed brushes or pens, and later quill pens. For convenience and economy, informal records and communications were inscribed on wax tablets which could be re-used by warming the wax to smooth out the surface. Few samples of

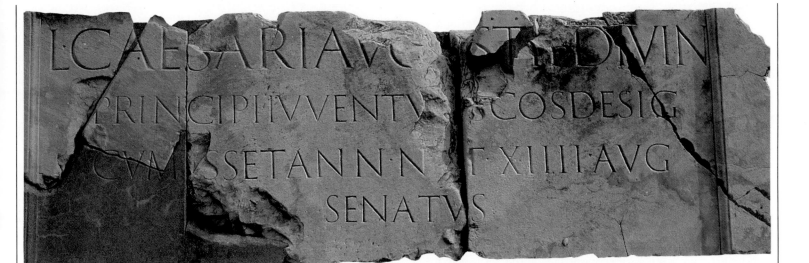

The clean proportions of Roman squared capitals are preserved in stone-carved monumental inscriptions, such as this senatorial address in honor of the Emperor Augustus (above), found damaged but still legible in the Forum at Rome. The weight of the lettering and subtle thick/thin variation in the strokes is perfectly maintained through both the large and smaller scale letters.

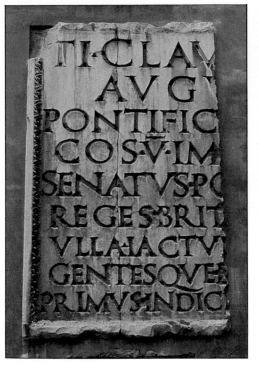

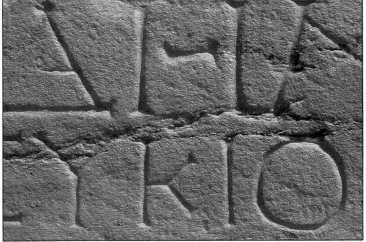

Fragments of Greek (above) and Roman (left) lettering in stone show the similarity of certain letterforms and the way in which the Romans developed a more formal, stately interpretation as the full alphabet sequence evolved. The slight roughness of the Greek letters indicates the difficulty of carving the linear forms into stone, a skill that the Romans brought to a high art. The channels of the letter strokes in this inscription from the triumphal arch of Claudius, dating from the first century BC, were originally filled with bronze.

Roman cursive writing have survived because of the perishable nature of these materials. But the easy movement of a flexible writing tool on a smooth, giving surface contributed to the modification of letterforms. In the later period of the Empire, parchment and vellum were commonly the supports for formal writing; these tough, natural materials made by refining animal skins fortunately have proved to be quite durable.

The regularly proportioned capitals, slow to write and, as subsequent research into legibility has shown, not easily read in large groupings, gave way during the late period of the Roman Empire to a book hand later given the name of uncial lettering. This is written with a square-tipped reed pen or quill and it is in this style of writing that the characteristic mark and motion of the edged pen first comes into its own without modification. Early uncials were written with the edged pen held at an angle, subsequently adapted to a horizontal approach. It is in the nature of this writing technique that the letters are rounded forms of weighty texture with emphatic thick/thin contrasts in the strokes, and no less attractive for this dense and solid quality.

As the influence of Rome declined, it was in the Christian scholarship of Europe that the new styles of writing evolved. Uncials, technically related to the Roman capitals and designated majuscule letters, developed into a form categorized as half-uncial. Whereas majuscules are, broadly speaking, written within a fixed height above the baseline, half-uncials first demonstrate the breaking of these writing lines, later to be extended into the rising and falling strokes – ascenders and descenders – that became the mark of a minuscule script. The finest examples are the Insular hands demonstrated in the English seventh-century Lindisfarne Gospels and the Irish Book of Kells of the eighth century. These styles were transmitted across the Continent by the activity of missionaries and traders, but a large number of variations were developing in formal and cursive writing styles, and the earlier cohesion provided by the dominance of the centralized Imperial administration was lost.

The next major development set in place the complete elements of modern writing styles. This was a revision of style and method in script lettering under the supervision of Alcuin of York, Bishop of Tours and master of the court school at Aachen in northern Europe, the seat of government of the Holy Roman Empire ruled by Charlemagne, King of the Franks. Charlemagne was attempting a vast cultural revival

This chart shows the chronological development of the alphabet and the evolution in styles of writing. Starting with the earliest forms of recorded language, the pictograms, ideograms and hieroglyphs of ancient civilizations, it demonstrates the gradual emergence of wholly abstract symbols representing sounds of speech, the establishment of the versatile but relatively few characters constituting the Roman alphabet, the division of capital letters and minuscule scripts, and the subsequent stylistic variations.

Ideogram / Pictogram

▼

Cuneiform 3500–2000 BC

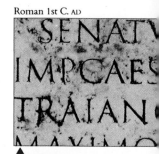

▼

Hieroglyph 3000 BC

Rustics 1st to 3rd C. AD

Square Capitals 1st to 4th C. AD

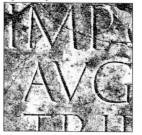

Roman 1st C. AD

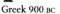

▲

Greek 900 BC

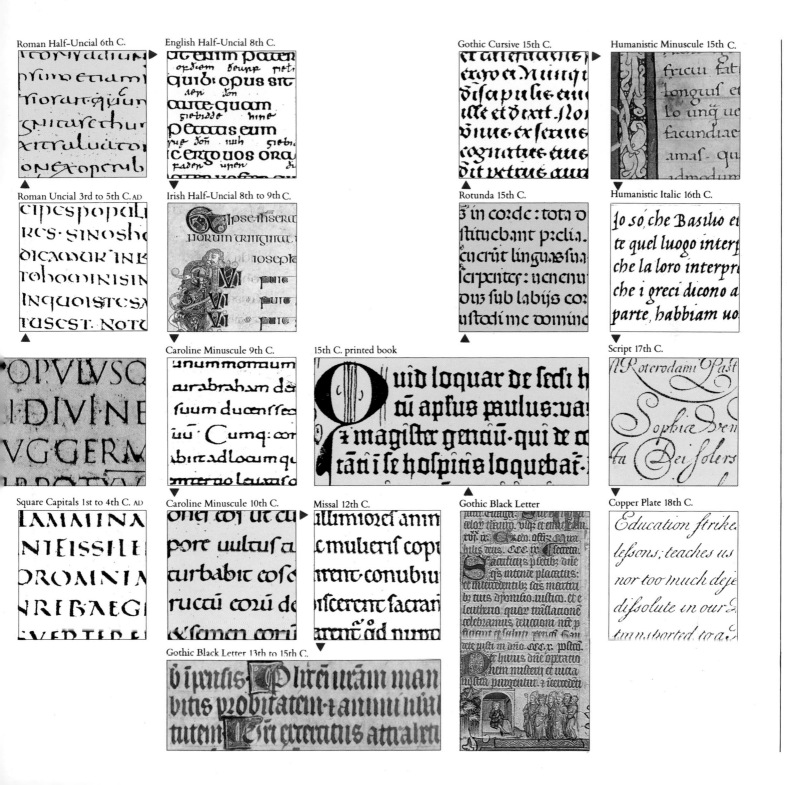

Roman Half-Uncial 6th C.

English Half-Uncial 8th C.

Gothic Cursive 15th C.

Humanistic Minuscule 15th C.

Roman Uncial 3rd to 5th C. AD

Irish Half-Uncial 8th to 9th C.

Rotunda 15th C.

Humanistic Italic 16th C.

Caroline Minuscule 9th C.

15th C. printed book

Script 17th C.

Square Capitals 1st to 4th C. AD

Caroline Minuscule 10th C.

Missal 12th C.

Gothic Black Letter

Copper Plate 18th C.

Gothic Black Letter 13th to 15th C.

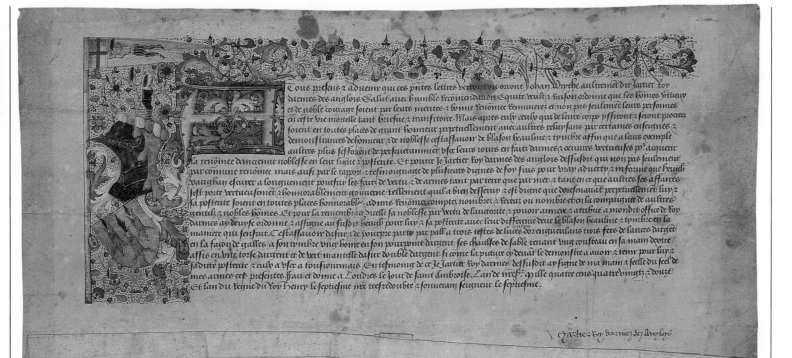

The development of book hands was accompanied by increasing skill in decoration of handwritten manuscripts, beautifully exemplified in the eighth-century Book of Kells (above left), written in half-uncial script and finely ornamented with colours. In the fourteenth-century St Denis missal (far left), the late Gothic script is executed in red and black and heavily decorated with pictures and motifs, given additional brilliance by the use of raised gold. The rounded humanistic script favored by the scribe of the early sixteenth-century Bentivoglio Book of Hours (left) is completely enclosed in the solidly colored and richly designed borders surrounding the text.

An English Grant of Arms (above), still bearing its original seal, displays twenty densely packed lines of an elegant, late Gothic cursive script, finely ornamented with a large illuminated capital and elaborately designed margin motifs which include the helmet and coat of arms. The grant was given in London in 1492. The script is extremely rich and even in pattern and texture. The slight slant of the writing and pointed ascenders mark it as a practical, rapid style, though sufficiently formal and ornamental for its purpose.

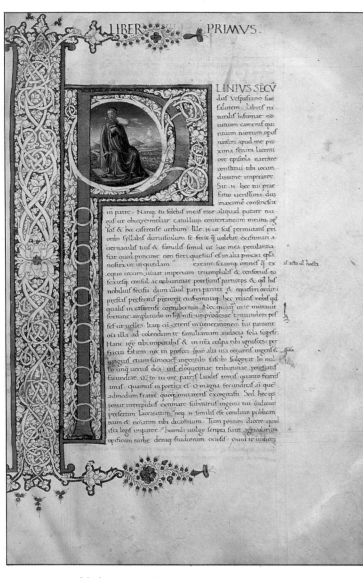

The association of the humanistic scripts with classical scholarship is demonstrated in this section of Pliny's Natural History, written by an Italian scribe of the mid-fifteenth century and richly illuminated. The small notations to the right of the text are an intriguing feature.

within his empire, and part of Alcuin's task included the study of all standard texts in order to eradicate corruptions caused by years of successive copyings. In the course of this work, a form of minuscule script was perfected which achieved a wide and lasting influence.

This ordered and practical script, called Carolingian minuscule after Charlemagne, finally clarified the distinctions between majuscule and minuscule letters, the basic structural differences which from that time on were applied in handwriting, formal calligraphy and printed lettering, in which they are described by the terms upper-case, or capital, letters and lower-case letters corresponding to the minuscules. (The term lower-case is used in certain of the alphabet texts in the second section of this book for convenience in referring to modified forms of minuscule letters and scripts.) Following the introduction of this minuscule, all further developments in the presentation of letterforms from the ninth century onward can be categorized as technical or stylistic, but not basically structural.

The minuscule, like the uncial, was a form natural to edged pen writing, and its visual characteristics evolved in different ways among the various regions where it took root. In northern Europe during the medieval period, minuscule letters became compressed and angled into the rich, heavily textured forms of Gothic scripts, also called Black Letter. The strictly regimented, vertically stressed, angular Black Letter known as Textura is familiar from many of the most beautiful illuminated manuscripts to have survived from the early Gothic period. The more loosely constructed and pointed Gothic cursive (running hand) retained a densely patterned quality typical of this high point of calligraphic development. The many variations of Black Letter that evolved in the later Gothic period are categorized as Bastarda, indicating that combined influences gave these scripts a less definitive form and character than the classic style of Textura.

In Italy and Spain the minuscule developed more along the lines of the original rounded constructions, and southern European scripts acquired the name of Rotunda. Gradually the scribes and scholars of Renaissance Italy refined the shapes and styling of the letters, producing a range of scripts broadly termed humanistic, and it was the development of the slanted and branching italic, an elegant but practical cursive style of writing, that proved to have a profound and long-term influence on future standards of lettering design and handwriting.

It must be remembered that up to this point, modifications to the forms of letters were not merely a matter of academic experiment or a whim to decorate the page. Hand copying was the only way of recording and transmitting important texts, and the Gothic cursive and later humanistic scripts were specially designed to perform this function more rapidly and efficiently. The invention of printing from movable types toward the end of the fifteenth century signaled the end of this long-established tradition, although the true effect took some time to gather momentum. Of greater immediate significance was the fact that it was the formal scripts of the Gothic and Renaissance periods in various regions of Europe that were used as the models for the newly created printers' types. An important exchange of influences was set up which has been actively renewed in recent decades.

The obvious advantages of printing spelled disaster for the traditional craft of scribes and copyists, although the continuation of their skills was to some extent still necessary for manuscripts and documents not intended for wide distribution. The function of the calligrapher was differently assessed, and gradually a new emphasis arose in the production of printed copybooks containing samples of fine writing, reproduced by the technique of engraving on copper. These succeeded in finding an interested public and heralded a productive period for the most skilled of the writing masters. Relieved of their strictly practical responsibilities, they were free to indulge the most inventive interpretations of basic letterforms. The ornamentation applied to the plates gradually became more extraordinarily elaborate and stylized. In many cases the standards of lettering design became thoroughly debased and inappropriate, but some of the finest samples, particularly in the eighteenth century, set the standard for handwriting used in commerce, administration and personal correspondence. With the spread of literacy in the approach to the modern era, calligraphic practice once again obtained a direct and useful social application.

With industrialization came improved methods of printing, and the nineteenth century was a barren period in terms of calligraphic style. An effective revival of calligraphy has taken place within this century, however, returning to the study of historical developments in writing and the traditional tools and materials of the craft. Although the disciplines of writing by hand and printing had become separated during the period of rapid industrial progress, renewed interest in the finest and most purposeful calligraphy of the past had brought the two

An unknown Spanish scribe of the early nineteenth century was responsible for this bright and vigorous document, written in a fine italic script which refers back to earlier styles. Even such a late work follows the established traditions of calligraphy: black text highlighted with red, linear and painted ornament enriched with gold, and a large initial capital enlivened by a small narrative scene.

ABCDEF
GHIJKLM
NOPQRS
TuVwXyz

The classical art of lettering is recovered in this modern reworking of Roman capitals (left), in this instance carved in the more yielding material of plaster rather than stone, but still finely calculated in the proportions and relationships of the letters. A free and vigorous interpretation of letters decorates a geometric motif accompanied by a printed text (below left), making use of the contrasts of white, black and a middle-tone blue. Lombardic lettering (below right) is treated to an experimental process. The original pen lettering was used to create a film mask through which washes of colored ink built up a vibrant textural effect.

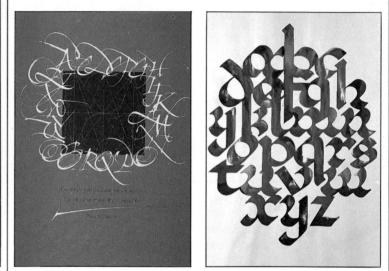

traditions closer once again. Some of the most skilled modern calligraphers have also been the designers of widely used typefaces. There is also much to be learned about possibilities in the design of calligraphy by studying the research and analysis applied to the effect of the printed word, since this has established the standards of legibility and visual presentation of letters to which modern eyes are trained. The rediscovery of the rich potential of calligraphy, totally free of the most mundane aspects of copying and recording, offers the present-day calligrapher a wealth of sources on which to draw in the course of learning the craft and developing a high degree of skill and invention.

The design of letterforms

The legibility of an alphabet form depends upon every letter retaining its most basic identifiable structure – the triangular, crossed shape of the capital **A**, for example; or the stem and bowl of **P**; the enclosed and open counters (interior spaces) of **O** and **C**, and so on. But this is essentially only the skeleton form of the letter, which can be built upon and elaborated by any number of techniques and devices. The calligraphy samples in this book have been specially selected to demonstrate how versatile are these basic forms and how many formal and decorative possibilities are applicable to the 26 alphabet letters in both their upper-case and lower-case forms.

One of the most significant factors affecting the visual appearance of a calligraphic letter is the writing instrument with which it is described. Brush-written lettering is different in feel from pen-written letters. The actual shape and texture of the pen further affects the appearance of the writing. The responsiveness of a hand-cut quill, still the favored tool of calligraphers, allows rather more fluidity than the relatively rigid metal pens, while the easy motion of a fiber-tip or fountain pen by its nature suggests a relaxed, informal style of script.

It is important to differentiate between calligraphy written with an edged pen – that is, one with a squared tip to the nib – and that executed with a pointed pen, since these tools

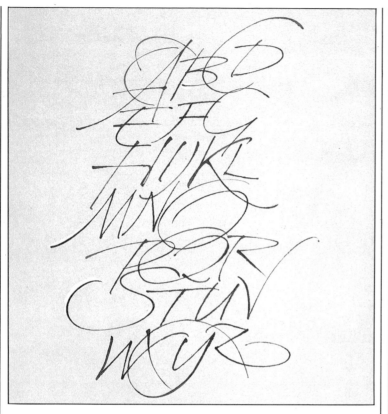

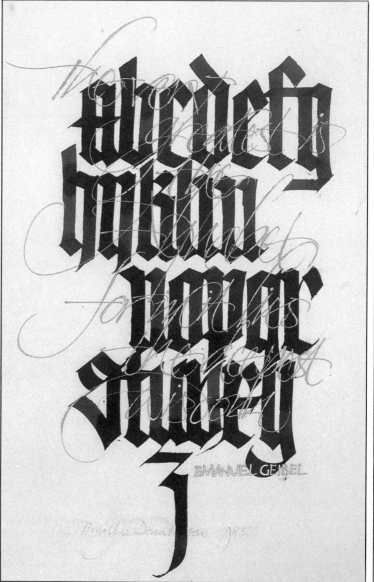

definitely dictate the basic style of the written letters. There is a historical difference here which for some time caused confusion in the technique and practice of calligraphy. By reference to the writing samples shown in the following pages it is immediately apparent that the chronologically earlier styles are typically of heavy or medium weight, with a striking modulation between thick and thin strokes and a definite directional balance or pull based upon this weighting of the pen strokes. These are the characteristics of edged pen writing, since whatever the pen angle, its movement naturally produces thick/thin variation according to whether it is the full width or the fine edge of the pen tip which is traveling on the surface.

Pointed pen lettering is invariably more linear and finely textured. The modulation in pen stroke has to be somewhat artificially created by varying the pressure on the nib, which, when heavily pressed, will splay slightly and put down a noticeably thicker line. Pointed pen writing was standard practice from the eighteenth century, and in study of previous

A rhythmic and elegant capital letter alphabet (above left) by modern scribe Robert Boyajian, is enlivened by the use of subtly contrasting colored inks applied from a fine ruling pen.

Gothic black letter, elongated and compressed, is the basis of this style (above), the heavy forms cleverly overlaid with a spidery script executed in shimmering blue-gray, an ambitious and highly successful combination of opposites.

This richly textured, symmetrical design demonstrates the continuing usefulness of one of the earliest forms of writing tool: a hollow reed trimmed and shaped to form a broad-tipped pen. The hazily random color changes derive from the medium used — an ordinary black writing ink which, when diluted, separates into cool blue and warm brown tones.

calligraphic forms, it was not fully realized that the weight of the letters came from use of a different type of pen. It was thought that the density of the lettering came from drawing the forms in outline and filling the strokes, using a pointed pen or similar tool. It was rediscovery of the vital element of edged-pen writing that stimulated the most recent and fruitful revival of interest in the calligraphy of the past.

These different intrinsic qualities also give rise to different techniques in writing. A pointed pen can with practice be pushed and pulled in any direction on the writing surface without interrupting the flow of the script. The hand and whole arm should be free to move – the form is not described by the action of fingers and wrist only.

An edged pen, by comparison, is much more easily drawn down the grain of the surface so that the edge and underside of the nib maintain the consistency of the stroke. When the pen is pushed upward and against the grain, the movement is obstructed and the stroke becomes irregular and imprecise, destroying control of the linear qualities. In formal calligraphy the movement of the edged pen flows downward from the top of the letter, and to complete a form it may be necessary to lift the pen from the surface at the termination of a stroke and return to an appropriate starting point to form the width and direction of the next stroke. This implies a natural order and direction for vertical, slanted and horizontal strokes, which is illustrated in the sample of Roman capitals on pages 28-9.

Much has been written about "correct" practice of calligraphy, but the most crucial factor is responsiveness on the part of the calligrapher – to the touch and movement of the writing tool on the surface, and to the relationships of letters and their internal proportions, the weight, spacing, texture and placement on the page. Proportion and balance are not governed by fixed standards; to a large extent the yardstick in calligraphy is simply whether or not the form or design looks right, and this is a judgment with a large degree of subjectivity involved.

While the purpose of calligraphic practice is generally geared toward the writing of formal and decorative texts, the basic structure and elaboration of the alphabet itself is the starting point. The samples collected here demonstrate that this has been the fascination of calligraphers over centuries. They are intended as a resource for the practice and development of writing skill. Their variety and expertise, from the most restrained and formal to the most curiously inventive, present a pattern of richly instructive elements at any time capable of being invested with new life.

The ALPHABETS

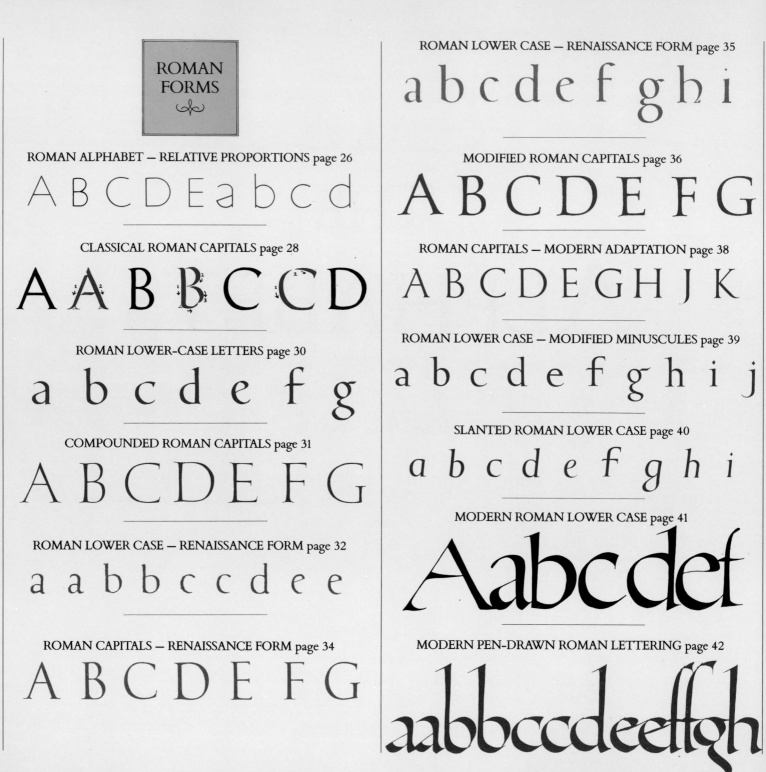

ROMAN FORMS

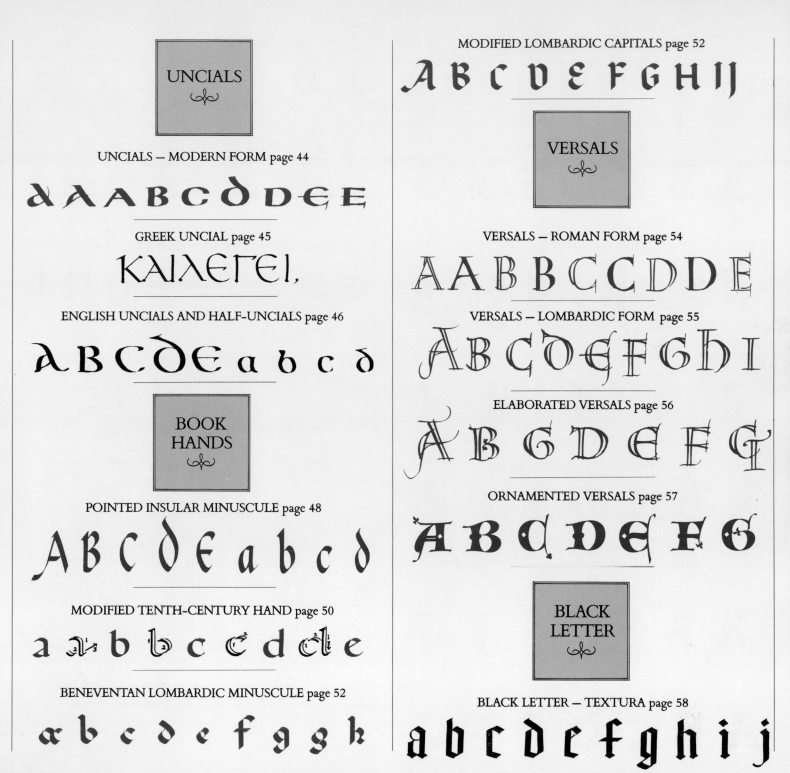

UNCIALS

UNCIALS — MODERN FORM page 44

GREEK UNCIAL page 45

ENGLISH UNCIALS AND HALF-UNCIALS page 46

BOOK HANDS

POINTED INSULAR MINUSCULE page 48

MODIFIED TENTH-CENTURY HAND page 50

BENEVENTAN LOMBARDIC MINUSCULE page 52

MODIFIED LOMBARDIC CAPITALS page 52

VERSALS

VERSALS — ROMAN FORM page 54

VERSALS — LOMBARDIC FORM page 55

ELABORATED VERSALS page 56

ORNAMENTED VERSALS page 57

BLACK LETTER

BLACK LETTER — TEXTURA page 58

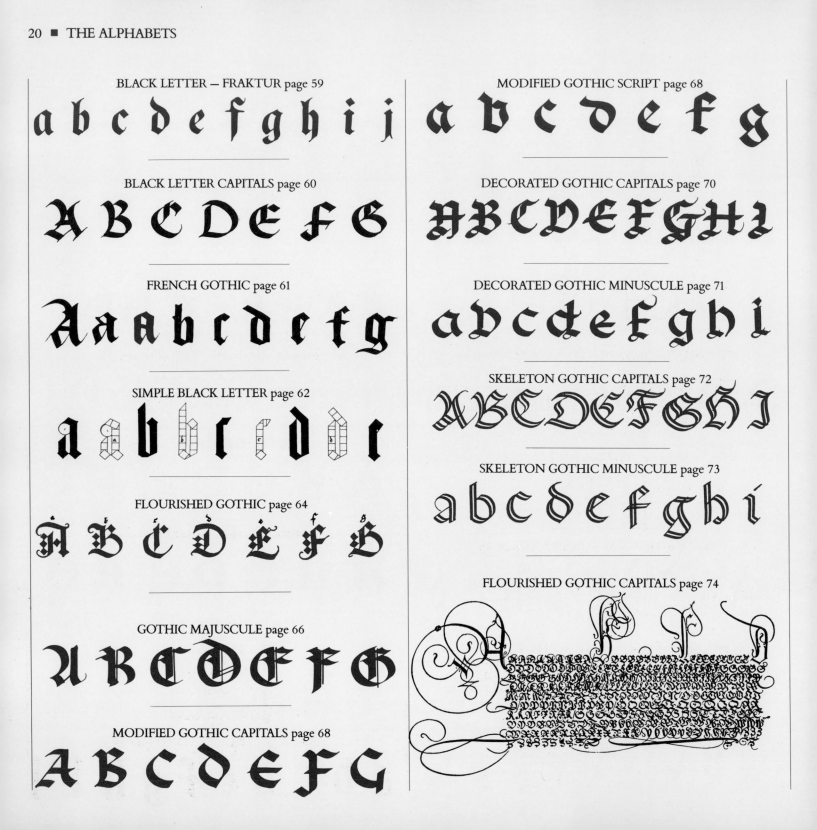

BLACK LETTER – FRAKTUR page 59

a b c d e f g h i j

BLACK LETTER CAPITALS page 60

A B C D E F G

FRENCH GOTHIC page 61

A a a b c d e f g

SIMPLE BLACK LETTER page 62

a a b c d e

FLOURISHED GOTHIC page 64

A B C D E F G

GOTHIC MAJUSCULE page 66

A B C D E F G

MODIFIED GOTHIC CAPITALS page 68

A B C D E F G

MODIFIED GOTHIC SCRIPT page 68

a b c d e f g

DECORATED GOTHIC CAPITALS page 70

A B C D E F G H I

DECORATED GOTHIC MINUSCULE page 71

a b c d e f g h i

SKELETON GOTHIC CAPITALS page 72

A B C D E F G H I

SKELETON GOTHIC MINUSCULE page 73

a b c d e f g h i

FLOURISHED GOTHIC CAPITALS page 74

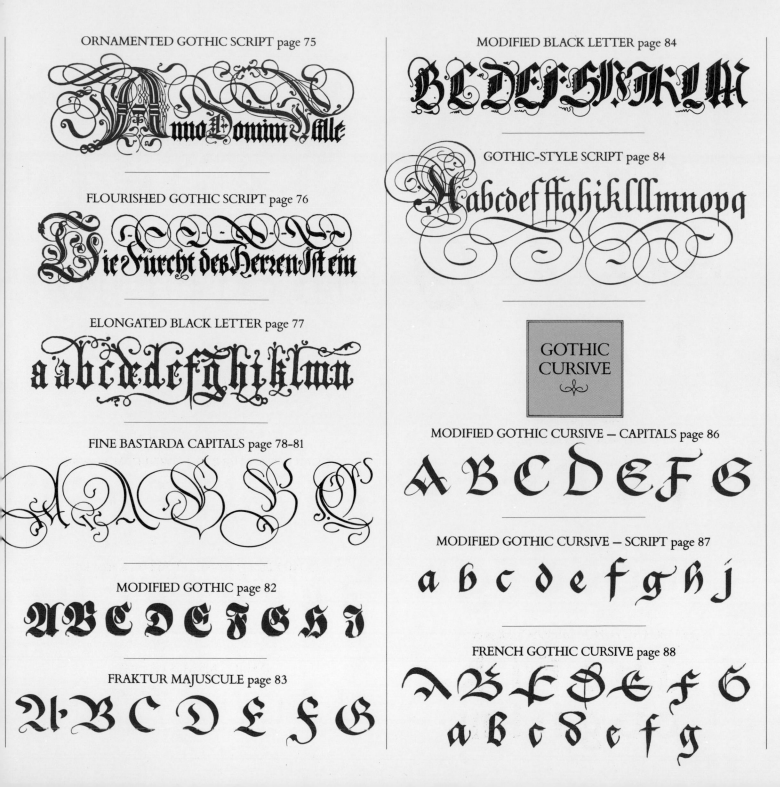

ORNAMENTED GOTHIC SCRIPT page 75

FLOURISHED GOTHIC SCRIPT page 76

ELONGATED BLACK LETTER page 77

FINE BASTARDA CAPITALS page 78-81

MODIFIED GOTHIC page 82

FRAKTUR MAJUSCULE page 83

MODIFIED BLACK LETTER page 84

GOTHIC-STYLE SCRIPT page 84

GOTHIC CURSIVE

MODIFIED GOTHIC CURSIVE — CAPITALS page 86

MODIFIED GOTHIC CURSIVE — SCRIPT page 87

FRENCH GOTHIC CURSIVE page 88

GOTHIC CURSIVE MAJUSCULE page 90

SCRIPTS BASED ON GOTHIC CURSIVE pages 91–93

ROTUNDA

ROTUNDA CAPITALS page 94

ROTUNDA MINUSCULE page 95

SPANISH ROTUNDA MINUSCULE page 96

ROCOCO page 97

DECORATIVE DOUBLE-STROKE ALPHABET page 98

DECORATIVE DOUBLE-STROKE LOWER CASE page 99

ITALICS

COMPRESSED HAND — LOWER CASE page 100

COMPRESSED HAND — CAPITALS page 101

ITALIC CAPITALS page 102

ITALIC LOWER CASE page 103

a b c d e f g h i

FINE ITALIC page 104

a b c d e f g h i

FLOURISHED ITALIC page 105

A A B B C D E F G G

DECORATIVE HUMANISTIC ITALIC page 106

A B C D E a b c d

COPYBOOK ITALIC page 108

A A B B C D D E E F F G G

FLOURISHED ITALIC page 109

a b c d e c f g g g g h i k k k l

ELABORATED ITALIC page 110

A A A A A A B B B B C C C D D D E E E E F F

SPANISH ITALIC CAPITALS page 111

A A A A B B B B

SPANISH ITALIC SCRIPT page 111

A a a b b c c d d e e f f f f

MODERN ITALIC ALPHABETS pages 112–114

A a b c d e f g h i j k l m

A a b c d e f g h i j k

A a b c d e f

FORMAL ITALIC page 115

a b c d e e f g h i

HUMANISTIC CURSIVE CAPITALS page 116

A A B B B C C D D

DECORATIVE ITALIC page 118

SLANTED GOTHIC page 119

COPPER-PLATE

FLOURISHED CAPITALS page 120

ROUND HAND page 122

COPPERPLATE SCRIPT page 122

POINTED PEN LETTERS page 124

POINTED PEN LETTERS page 124

FINE GOTHIC-STYLE SCRIPT page 126

ROUND TEXT page 126

SQUARE TEXT page 127

ROUND HAND page 127

REVISED HUMANISTIC SCRIPTS page 127

FLOURISHED SCRIPT LETTERS page 128

FLOURISHED CAPITALS page 130

FLOURISHED CAPITALS page 129

MODERN
LETTERS

FINE CAPITALS page 132

MODERN GOTHIC page 133

TRIPLE-STROKE ALPHABET page 134

CURSIVE LETTERING page 136

SCRIPT ALPHABET page 138

FLOURISHED CAPITALS page 139

FINE PEN-DRAWN LETTERS page 140

BROKEN LETTERS page 142

SOLID SQUARED CAPITALS page 143

MODULATED CAPITALS page 144

ROMAN FORMS

ROMAN ALPHABET – RELATIVE PROPORTIONS

These finely drawn skeleton letters show the relative proportions of the distinctive letterforms in the Roman alphabet, offering a basic model which may be clad with the different features of a fully styled or designed alphabet. The capital letters are standardized on the proportions of a full square, eight-tenths the width of the square, or half its width. Minor variations occur: in **M** and **W**, for example, the outer strokes fall outside the boundary of the square, while the slanted strokes of **X** and **Y** extend beyond their proportionate rectangle. The fine linear forms of **I** and **J** are the obvious exceptions to the rule. There is a greater degree of variation in the forms of lower-case letters. These structures relate specifically to upright rather than compressed or italic letterforms. However, the relationships between the basic shapes of the letters are the foundation of a well-designed alphabet, and a system of relative proportion underpins the design of even the most complex lettering.

$\frac{10}{10}$

CDGMOQW
+ +

$\frac{8}{10}$

HUNTAVZ

$\frac{5}{10}$

BEFKLPRSXY
++

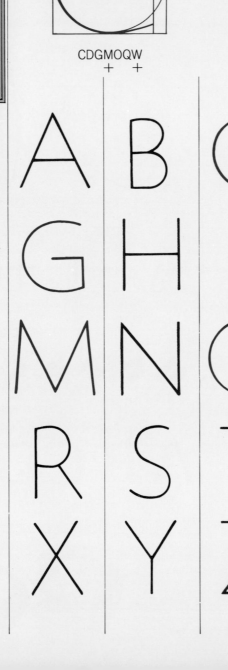

The Romans, who produced the most beautifully proportioned alphabet ever created, spent many years perfecting these letterforms. They considered lettering one of their major arts. These skeleton forms are closely based on those proportions, which relate to square and circle.

$\frac{10}{10}$

omw

$\frac{9}{10}$

bcdegpq

$\frac{8}{10}$

huntavyz

$\frac{6}{10}$

fkrsx

a b c d e f g

h i j k l m n o

p q r s t u

v w x y z

* The fine, linear forms of the lower-case letters **i**, **j** and **l** are exceptions to this rule of proportion, as are **I** and **J** in the upper-case alphabet.

This skeleton lower-case letter is based on a Carolingian minuscule, developed during the ninth-century reformation of letterforms ordered by the Emperor Charlemagne. The Romans did not have a small letter, as we know it, although their half-uncial characters were the precursors of our lower-case letters.

CLASSICAL ROMAN CAPITALS

The elegant style of classical Roman capitals survives most clearly in the stone-carved inscriptions of imperial architecture and monuments. This alphabet is a modern pen-written version based on those carved forms. The accompanying diagrams show the order and direction of the pen strokes by which the character is formed: the square-tipped pen is drawn across the paper, never pushed against the grain, and with the nib edge at an almost constant 30° angle, the strokes are automatically finer when traveling diagonally from right to left, thick when drawn on a diagonal from left to right. The serifs, or finishing strokes, are modeled on the style originally typical of chiseled lettering; they are not natural pen forms, and they require a delicate touch and some dextrous manipulation of the pen.

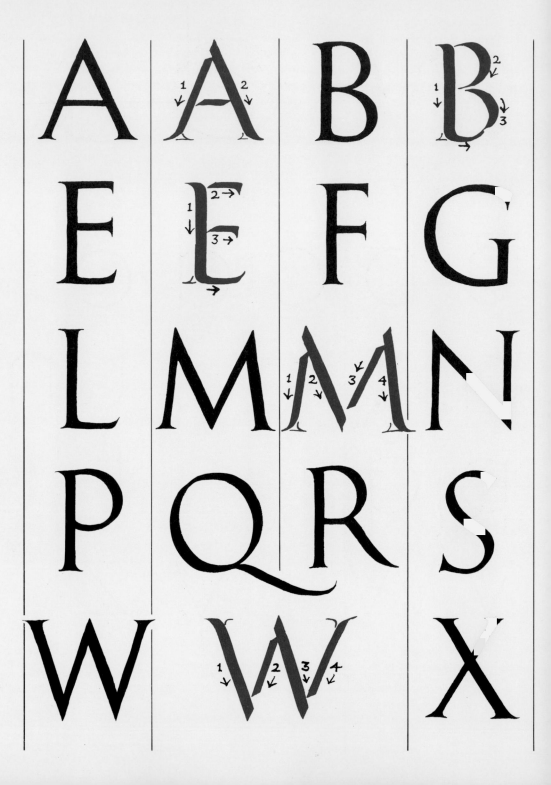

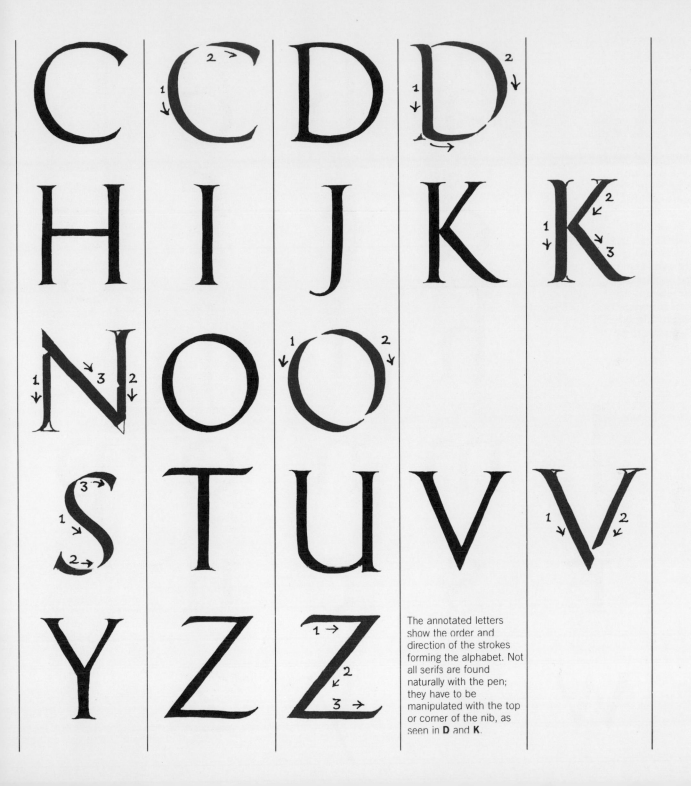

The annotated letters show the order and direction of the strokes forming the alphabet. Not all serifs are found naturally with the pen; they have to be manipulated with the top or corner of the nib, as seen in **D** and **K**.

ROMAN LOWER-CASE LETTERS

This alphabet is designed as a complement to the preceding capitals; the flat Roman serifs are seen in **k**, **v**, **w**, **x** and **y** and at the base of each letter, while the verticals have slanted serifs formed by a slight sideways and upward movement in beginning the stroke, before the pen is pulled smoothly downward. There was no directly comparable contemporary form of what are now called lower-case letters corresponding to the original Roman capitals. The shorter, more rounded forms with ascending and descending strokes were fully evolved in early minuscule scripts, which in turn were re-adapted by later writing masters and type designers to an overall style and proportion corresponding to the classical squared capitals.

a b c
d e f g
h i j
k l m n o p
q r s t u
v w x y z

These Roman minuscule letters are formed directly with the pen and are based on the skeleton lower-case alphabet on page 27, with slight variations. Angle of pen is 30° except for base serif formation.

COMPOUNDED ROMAN CAPITALS

Delicate proportions and finely varied strokes create a sophisticated modern adaptation of the Roman squared capitals. In this case the thick and thin stroke variations do not correspond to the actual pen width: the heavier vertical stems and swelling curves are created by outlining the shape and filling in with solid color, in a manner similar to the traditional rendering of decorative versals (see pages 56–7). Fine hairlines are used to terminate the individual elements, cutting across the width of the vertical and diagonal strokes with a deliberate yet subtle emphasis. There is no attempt to round out the serifs as in the classical Roman capitals.

A B C D
E F G H
I J K L
M N O P Q
R S T U
V W X Y Z

Built up letterforms are almost always in color. The skeleton of the letter is drawn and filled with fluid color. The fine serif is in lieu of the Roman serif.

ROMAN LOWER CASE – RENAISSANCE FORM

Giovan Francesco Cresci (*c* 1534 – after 1600) was one of the most influential of the sixteenth-century Italian writing masters, producing a number of printed books reproducing his demonstrations of various alphabets. This is a woodcut interpretation of pen-drawn lower-case Roman letters, a good example of the styles current at the time when printers' types were being developed. As was common in copybooks, some letters are given in different constructions – **h** is shown in two versions and **s** is demonstrated both as the now-familiar small letter and as the long character seen in medieval scripts. There are interesting forms in the double **f**, crossed and uncrossed, the double **g**, joined and lapping, and other examples of commonly used ligatures (joined letters).

During the Renaissance there was a revival of interest in classical inscriptions, and a re-introduction of interest in Carolingian minuscule of the ninth century. This produced a script based on those letters referred to as the Humanist minuscule.

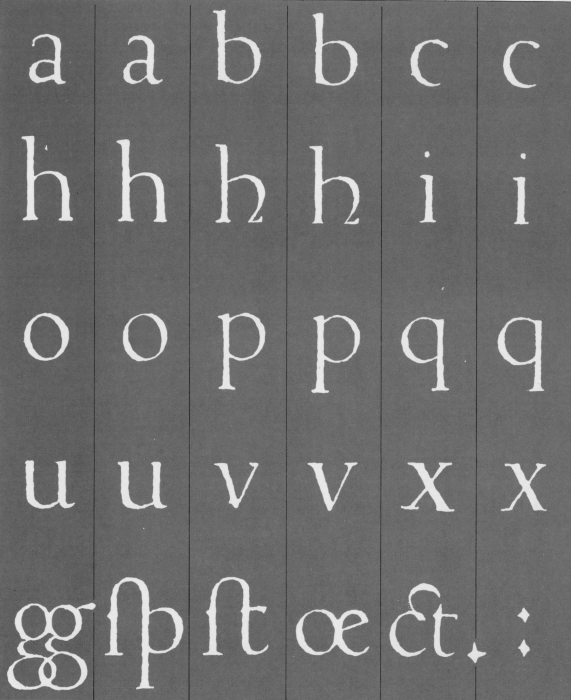

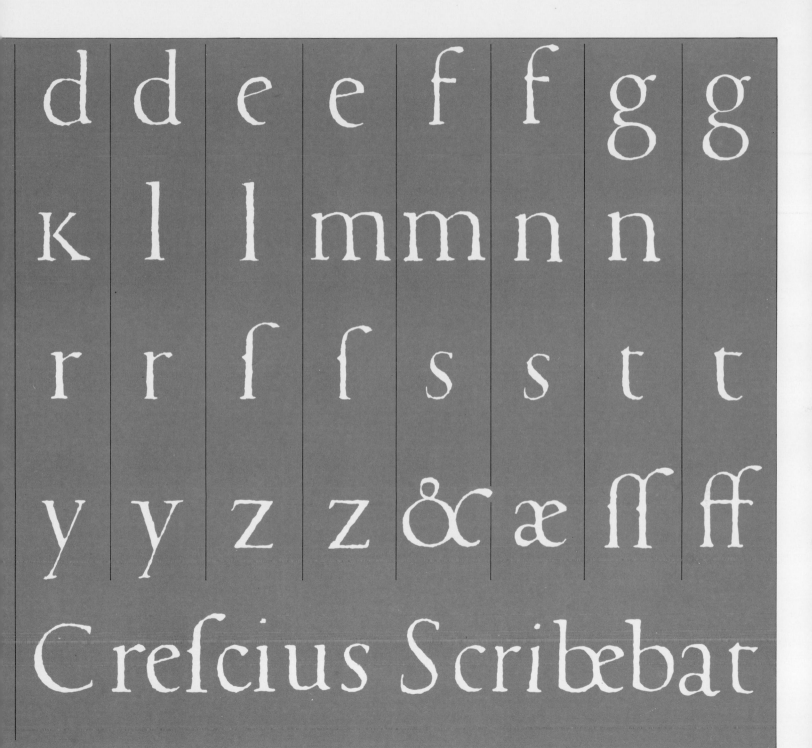

ROMAN CAPITALS – RENAISSANCE FORM

Another example from Cresci's woodcut-printed lettering samples shows a variation on the Roman capitals in which some of the characters are slighly narrowed when compared with the original classical forms; the letter strokes are typically weightier, the serifs flattened and heavy. Printed copybooks were devised as far as possible to reproduce faithfully the precise features of pen-written letters, but the medium of woodcut does not lend itself entirely to the essential fluidity of the pen's movement.

The Roman letter continued to be a source of inspiration throughout the centuries and particularly so during the Renaissance in Italy. The classical proportions were retained, sometimes confined to mathematical construction. Serifs were sometimes squared and the letters achieved a heavier character. Cresci regretted that the woodblock printed letterforms sometimes lacked the precision of his original pen forms.

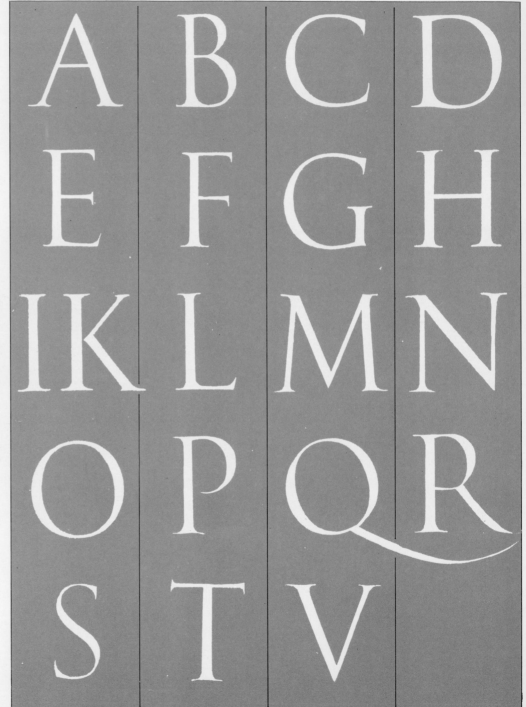

ROMAN LOWER CASE – RENAISSANCE FORM

These lower-case letters have a solid overall consistency enlivened by deliberate variations in certain individual features of their design. The pattern of squared serifs at the bases of the letters and descending strokes is contrasted with the hooked terminals of **a** and **e** and the slightly curved or slanted serifs on the vertical strokes of **b**, **d**, **h**, and **l**. The closed lower loop of the **g** is a standard feature of lower-case Roman alphabets which survives in modern-day typefaces, compared with the usually open tail of the italic small **g** when it is hand written. In this alphabet the **h** has an incurving arch and hooked serif reminiscent of the uncial form (see page 44).

Some of these letters appear to have a brush influence. The serifs are thickened, possibly because of the woodblock technique.

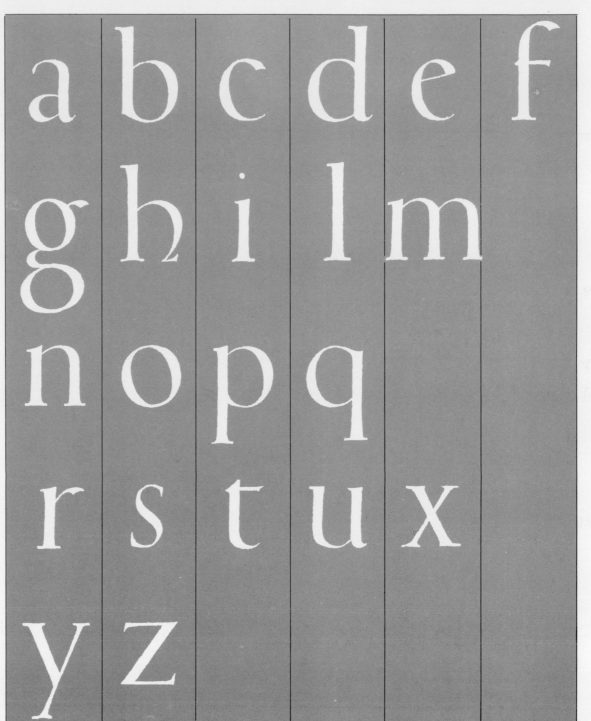

MODIFIED ROMAN CAPITALS

This is a well-adapted modern interpretation of the standard form of Roman squared capitals, elegantly proportioned and with strong but fluid variations between the thick and thin pen strokes. The fine, subtly curving serifs form slightly extended terminals to the main strokes. The lettering has a lightweight, open feeling enhanced by the broken counters of **P** and **R**, where the curving stroke forming the bowl of the letter does not quite reconnect with the main vertical stem. The numerals are carefully designed as a complement to the lettering, contained within a fixed height with no rising or descending strokes breaking through the lines. Numerals of this type are, of course, a replacement for the original system of Roman numerals constructed from the characters **I**, **V**, **X**, **L**, **C**, **D**, **M**. The squared oval form of the zero neatly and logically distinguishes itself from the rounded capital **O** of the alphabet.

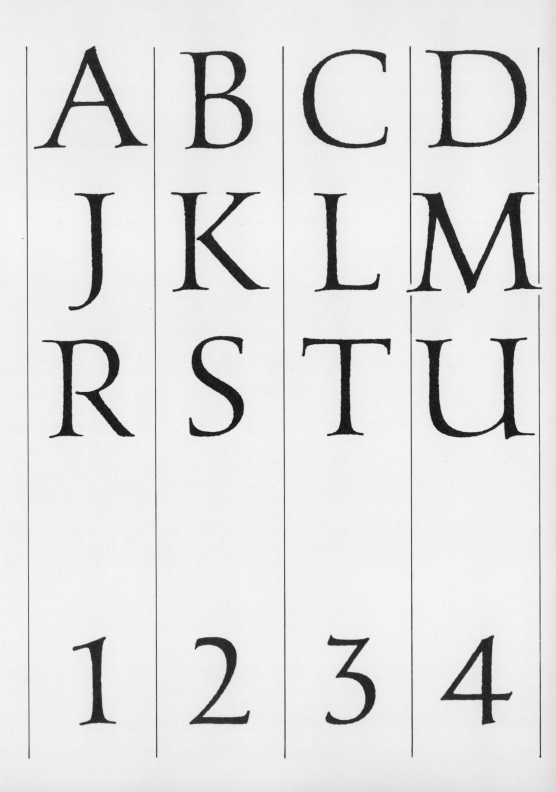

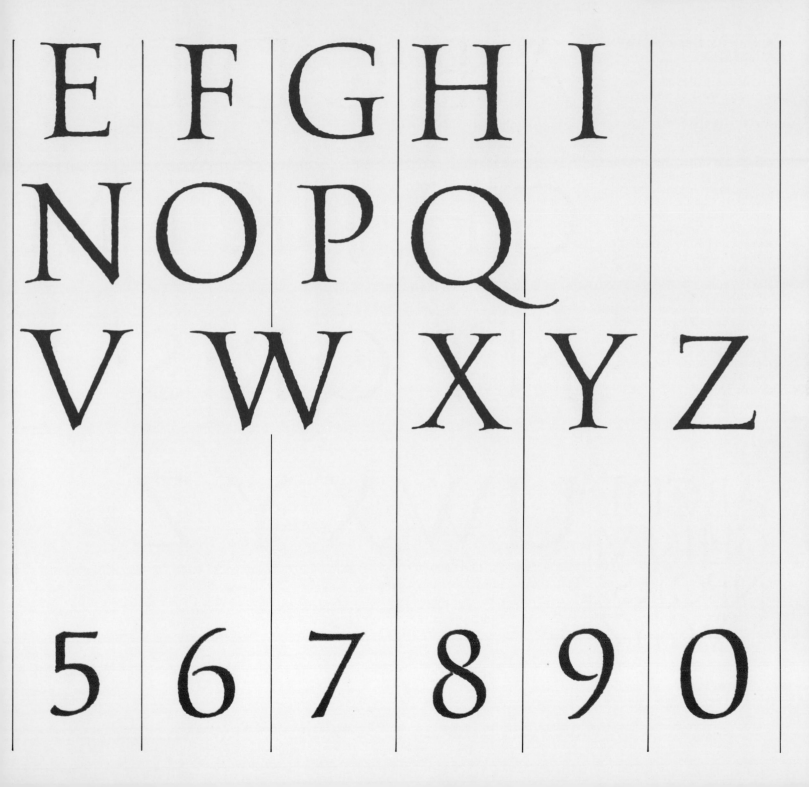

ROMAN CAPITALS – MODERN ADAPTATION

This modified version of Roman capitals is adapted to the foundational style of calligraphy developed in the early twentieth century, when modern scribes carefully studied and reinterpreted the lettering of early pen-written manuscripts. While adhering to the formal proportions of the letters, the alphabet has been designed as if it were a text. **L** and **Y** have been presented in a smaller scale (below), to adjust the overall spacing of the four lines of lettering and produce a balanced texture throughout when used *en bloc*. The letters **F**, **I**, **O**, **T** and **V** have been omitted, but these can easily be worked out by reference to other forms. The upper branches of the **Y** form a broad, open angle while the inner strokes of **W** are designed to cross rather than meet at the top of the letter, emphasizing its appearance as a double **V**.

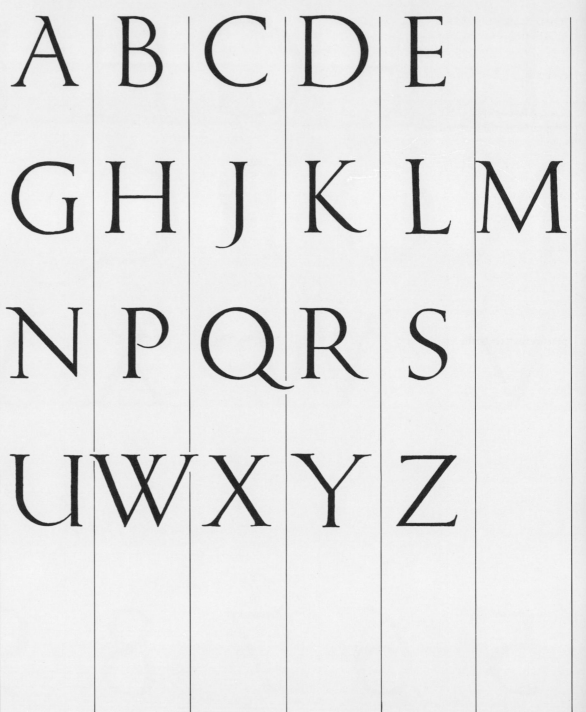

ROMAN LOWER CASE – MODIFIED MINUSCULES

These fluid and well-proportioned letters represent a marriage between the pen-written minuscule letters of early medieval manuscripts and the upright, even style of lettering in classical Roman design. Modern calligraphy is characterized by a continuous reassessment of the evolution and development of alphabets. The combination of two or more styles can offer subtle variations in design which lead to a satisfying and lively reworking of traditional letterforms. The swelling curves and flowing verticals of these letters are enhanced by the use of fine hairline serifs and extended terminals. It is a modern version, but this style of lettering was also current in the eighteenth century, during a period of classical revival, and it was at that time common practice to describe the letters with a brush rather than a pen.

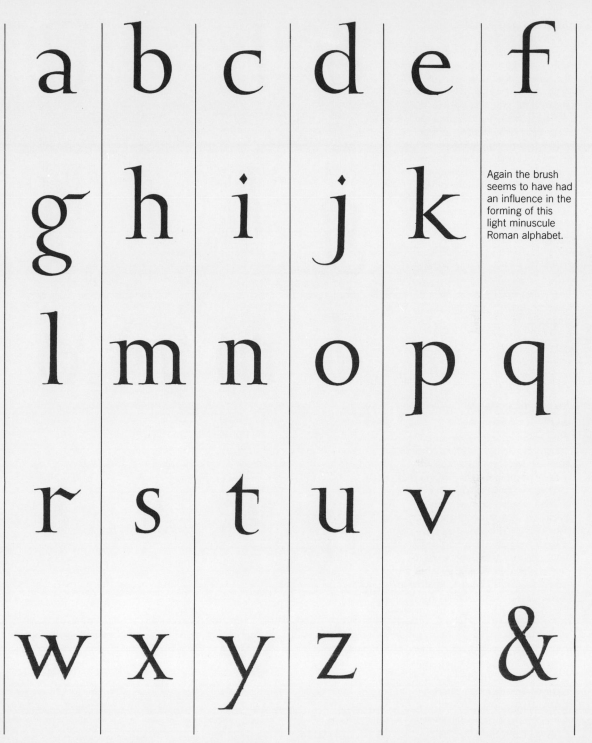

Again the brush seems to have had an influence in the forming of this light minuscule Roman alphabet.

SLANTED ROMAN LOWER CASE

The distinctive slant of these letters refers to italic writing, as do the oval counters of **o**, **b**, **d**, **g**, **p** and **q**. But there is a generosity in the width of the oval, and the letterforms are devoid of the sharply arched and branching strokes that characterize a true italic. The flattened, horizontal serifs come from the basic style of classical Roman lettering, but the subtle slanting is nicely emphasized by the drawn-out tails of **j** and **y** and the tight angle formed where the loop of the **g** returns to the baseline.

MODERN ROMAN LOWER CASE (*opposite*)

Here again, the alphabet is used to construct a densely textured pattern. Interlocking forms and crossed strokes develop the character of the design, but the intrinsic shapes of the individual letters are perfectly preserved. Particular features are introduced to fill and shape the overall design of the text. The **f** is finely narrowed to fit between the rounded shapes of **e** and **g**, while the capital form of **Q** is used, adapted to lower-case proportions, so that the drawn-out tail travels broadly across the slanted strokes of **w**. The central cross-stroke in the **z** is a device often favored by calligraphers to add extra horizontal emphasis to the letter, balancing the fineness of the right-to-left diagonal. This is a particular feature of northern European style, more commonly seen in Gothic alphabet forms.

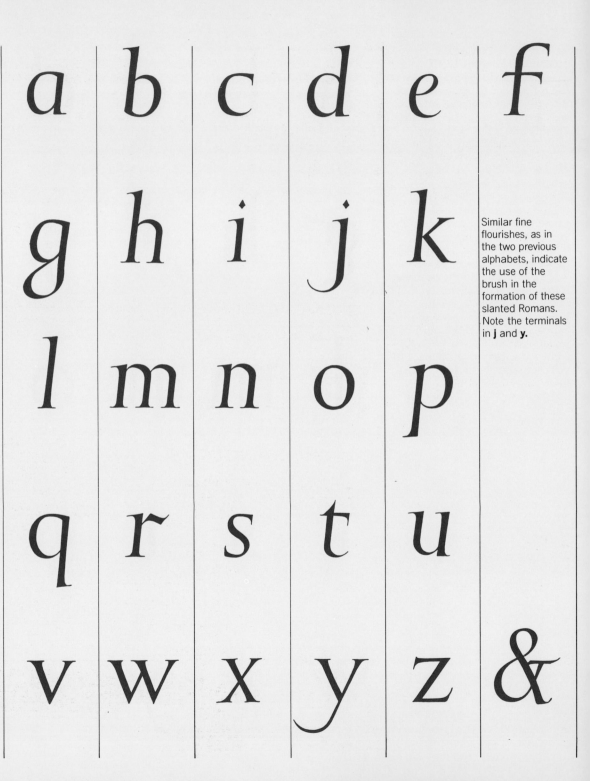

Similar fine flourishes, as in the two previous alphabets, indicate the use of the brush in the formation of these slanted Romans. Note the terminals in **j** and **y.**

Aabcdefghijklmnopqrstuvwxyz

The designer of this and the following alphabet has produced lively letterforms, demonstrating an overall pattern of massed and sometimes interfaced letters.

MODERN PEN-DRAWN ROMAN LETTERING

This freely worked lower-case alphabet written by the American scribe Arthur Baker employs unusual elongation of extended strokes, although the body of the forms is rounded. Exaggerated thick/thin contrasts weight the bowls of the letters at a low angle. The slashing verticals and flourished tails cut through the solid, even texture, which is created by the use of interlocking forms and repeated letters. All these elements have been carefully thought out in the arrangement of the alphabet as a complete design form. The fluid tracks of the broad-nibbed pen show how the practiced calligrapher can invest simple letterforms with a lively spontaneity while preserving an overall balance.

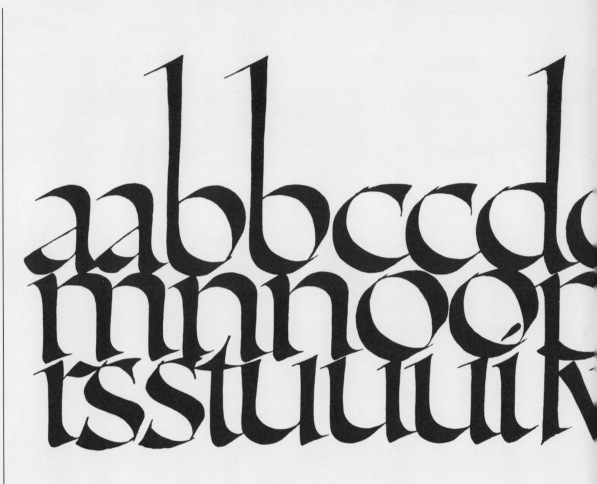

abcdeeffghhiiijkl
mmnopqrsqrrrhrr
tuv yvwx lyzzz

This lively Roman lower-case letter emphasizes the pattern value of letterforms, drawn very freely, although designed *en bloc*.

UNCIALS

UNCIALS – MODERN FORM

Uncial letters were a development of Roman capitals. The curving shapes were more rapidly and easily written with an edged pen than were the angular capitals, and uncials became the main book hand of the late Roman Empire and the primary form in Christian manuscripts up until the eighth century AD.

This modern version of an uncial alphabet shows the basic similarity in body height between the letters, although this style marked the beginning of rising and descending strokes which subsequently, through the half-uncial, became characteristic of minuscule and lower-case letterforms. A number of variations arose in the design of individual letters: particularly in **A**, **D**, **H**, **M**, **N**, **T** and **W**, there are alternative forms which roughly correspond to the typically differentiated identities of subsequent capital and minuscule alphabets. Uncials are generally fairly heavy letters written with the flat edge of a square-tipped pen. But, as can be seen from the written sample, they form an immensely rich and descriptive texture, all the more elegant for the finely hooked terminals and hairline flourishes.

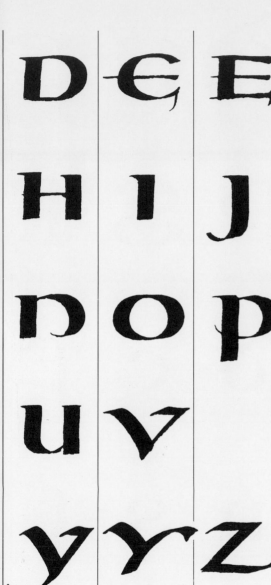

GREEK UNCIAL

The Roman alphabet derived directly from the Greek, and the uncial form of lettering was also appropriately used by scribes to convey standard texts in the traditionally scholarly language of Greek. This version was written by the English scribe Edward Johnston (1872–1944), whose diligent research into early manuscripts contributed greatly to this century's revival of some of the most beautiful calligraphic forms from the past. His rendering of these Greek letters would have been based most accurately on an original manuscript. The letterforms are almost skeleton-like compared with the Roman uncial previously illustrated. They have a similar squared and even formulation, but although the thick/thin variations of the edged pen can be identified, the fine linear consistency suggests use of a relatively narrow nib – probably that of a hand-cut quill pen, since Johnston favored the traditional tools of calligraphy as well as the authentic historical alphabet forms.

ΚΑΙΛΕΓΕΙ,
ΓΡΑΨΟΝ·ΟΤΙΟΥΤΟΙΟΙΛΟΓΟΙ
ΠΙСΤΟΙΚΑΙΑΛΗΘΙΝΟΙΕΙСΙ.
ΚΑΙΕΙΠΕΜΟΙ,ΓΕΓΟΝΑΝ.
ΕΓWΤΟΑΚΑΙΤΟW,
ΗΑΡΧΗΚΑΙΤΟΤΕΛΟС.
ΕΓWΤWΙΔΙΨWΝΤΙ
ΔWСWΕΚΤΗСΠΗΓΗС
ΤΟΥΥΔΑΤΟСΤΗСΖWΗС
ΔWΡΕΑΝ.ΟΝΙΚWΝ
ΚΛΗΡΟΝΟΜΗСΕΙΤΑΥΤΑ,
ΚΑΙΕСΟΜΑΙΑΥΤWΙΘΕΟС,
ΚΑΙΑΥΤΟСΕСΤΑΜΜΟΙΥΙΟС.

These letterforms seem to have a universal appeal — perhaps because of their rich round shapes. Their weight is strong: about four nib widths to the height. The uncial is very adaptable;and although the pen is usually held horizontally, it can also produce other characteristics when drawn at an angle.

ENGLISH UNCIALS AND HALF-UNCIALS

This alphabet shows another modern transcription of the early uncial form, followed by a half-uncial alphabet, the book hand which followed on from uncials. In this case the half-uncials are based on early English lettering from the beautifully decorated Lindisfarne Gospels, written in the seventh century AD. In the half-uncials, the characteristics leading to minuscule, or lower-case, forms are readily apparent. This is a systematic and formal script, with deliberate ascenders and descenders breaking out of the body height of the letters. Despite the lingering reference to the capital form of **N**, this is otherwise the precursor of lower-case forms, and it is particularly noticeable that the semi-capitalized **A** still in use in the uncial alphabet has been completely modified into the more rounded, compact character appropriate to the half-uncial script.

aBcdef
opqrst

abcdef
opqrst

PaTER NOSTER,qui

g h i k l m n

u v w x y

s h i j k l m n

u v w x y z

est in coelis : sancti

BOOK-HANDS

POINTED INSULAR MINUSCULE

One of the first true minuscule hands was developed by Irish scribes, and this type of angular, compressed script was adopted in England and transmitted to other parts of northern Europe by Christian scholars. This alphabet is a modern version of the ninth-century Anglo-Saxon form – a rich, dense script given an engagingly ragged quality by the pointed terminals. It appears in the Lindisfarne Gospels as a gloss (translation of the text) written between the lines of the original uncial lettering. The modified capitals and numerals shown here are designed to accompany the minuscules; capital letters were used infrequently by the early scribes, so this is a derivation from the traditional forms, logically developed on the style of the script letters. The simplified shapes, angular compression and absence of flourishes contribute to rapid but consistent writing of this minuscule.

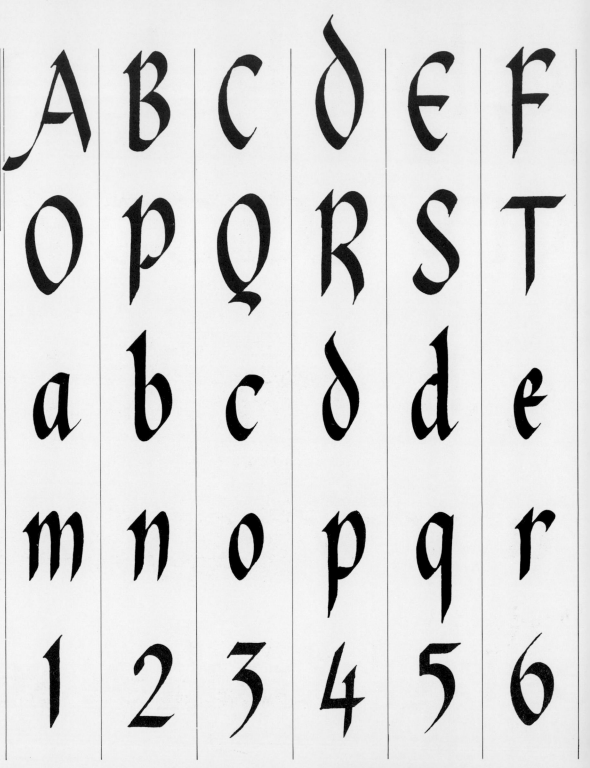

G H I J K L M N

M T U V W X Y Z

F Ʒ g h i j k l

S T U V W X Y Z

7 8 9 0

This Anglo-Saxon writing may have developed from cursive writing. The angle of the pen is steep with compressed letter shapes and remnants of earlier half-uncial letters. Note **f** and **t**.

MODIFIED TENTH-CENTURY HAND

A systematizing of minuscule scripts in northern Europe was deliberately initiated by the Emperor Charlemagne toward the end of the eighth century. Thereafter, although there were still many local variations in the style of letterforms, there was a widespread tendency to favor this type of rounded, cleanly spaced lettering. This modern sample, based on tenth-century English manuscripts, has a regular system of proportion, upright appearance and vigorous modulation between thick and thin strokes corresponding to the consistent movements of the edged pen held at a constant angle of 30°. A brief movement from left to right creates a simple serif leading into the downward verticals. Terminals at the letter bases and in the descenders of **g**, **p**, **q** and **y** are the natural pen curves flowing directly from the main strokes. This gives a basic rhythm to the letterforms which is translated into a lively, rolling texture when they are assembled into a text.

In the period when such minuscule hands were current, there was still a convention of using uncial and versal letterforms as initial capitals and for the important features of the text. The alphabet of capital letters shown here is a modern construction based on the form and proportion of the Roman alphabet, and it is invested with a similar fluidity to the lower case while retaining a solid, squared texture appropriate to the rounded weight of the small letters. Fine hairline flourishes on the horizontal strokes and finishing the bases of certain letters enliven the texture and create a linking device between the basically upright forms.

d d e e f f g g

l m m n o o p p

t t u u v v w w

adte confugi=doce facere

G H I J K L M N

U V W X Y Z & ! ?

BENEVENTAN LOMBARDIC MINUSCULE

The twelfth-century book hand known as the Lombardic or Beneventan script was developed in southern Italy and remained in use for almost 500 years. In its original style it is not easy to read, although in formal terms the angled lettering produces a strangely attractive zig-zag pattern in the text. The clubbed ascenders are relatively extended compared to the body height of the letters and this modern revision of the original style shows clearly the curious construction of certain letters; for example the exaggerated curves of **a** and **v**, and the narrow, somewhat angular **t**. It is generally a broad letterform, written with an edged pen held at a consistent 45° angle to produce compact shapes with emphatic thick/thin contrasts.

MODIFIED LOMBARDIC CAPITALS

Clear forms of undecorated capitals are visible in eleventh-century manuscripts employing the Beneventan script. These authentic letterforms have been used to reconstruct a full capital alphabet corresponding to the minuscule sample illustrated here. The pen angle is unambiguously demonstrated in the lozenge-shaped **O**, with its abrupt, slanted junction between the heavy side strokes rather than the rounded curve of earlier letterforms. It also naturally creates the angular serifs and pointed bases on the vertical stems. The numerals are also developed on the basis of the character of the original script. Put together with the minuscules, all these elements form a densely textured, heavyweight script.

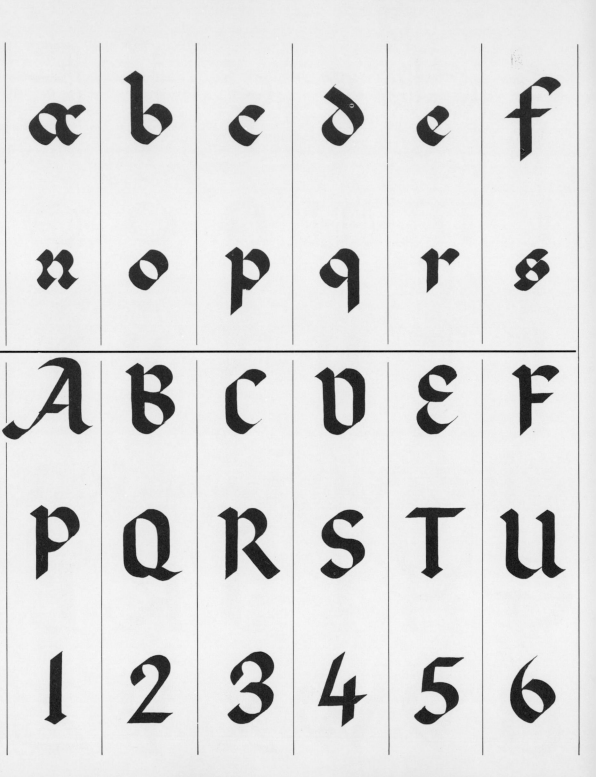

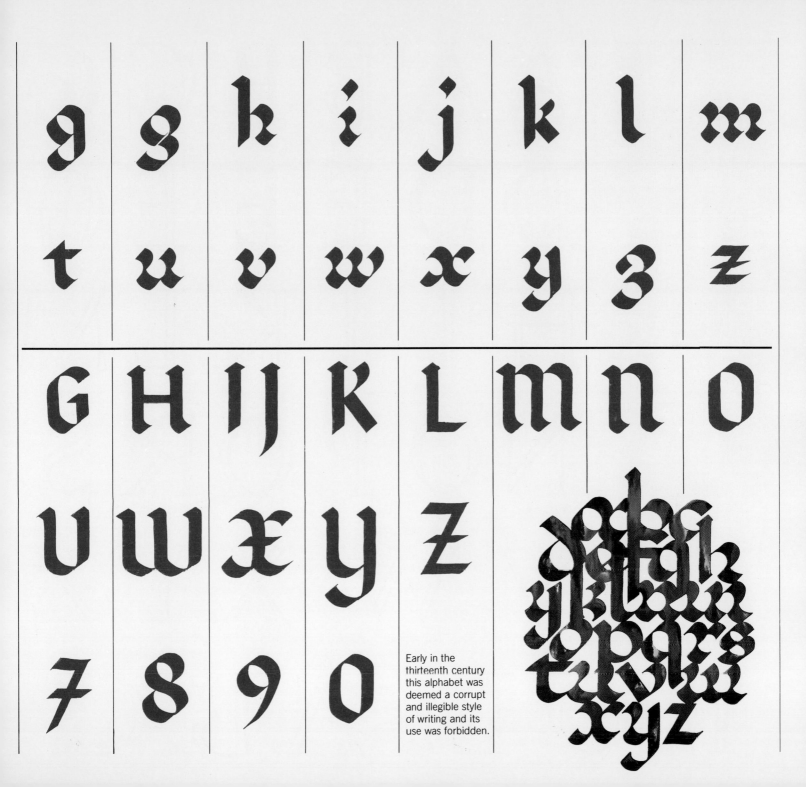

g g h i j k l m
t u v w x y z

G H IJ K L M N O
U V W X Y Z
7 8 9 0

Early in the
thirteenth century
this alphabet was
deemed a corrupt
and illegible style
of writing and its
use was forbidden.

VERSALS

VERSALS – ROMAN FORM

Versals are decorative capital letters originally used individually for the initial letters beginning the chapters, paragraphs or verses in a text. These were in use over many centuries and designed to accompany a variety of other letterforms. These simple versals are in a style based on Roman capitals, as commonly used in early manuscripts. The important characteristic of versals, compared to other calligraphic lettering, is that the letterforms are built up gradually rather than written fluidly. The pen is narrower and more flexible than that used to write the text. In this sample (left), fine hairline serifs complete the forms; these are in lieu of the proper Roman serif.

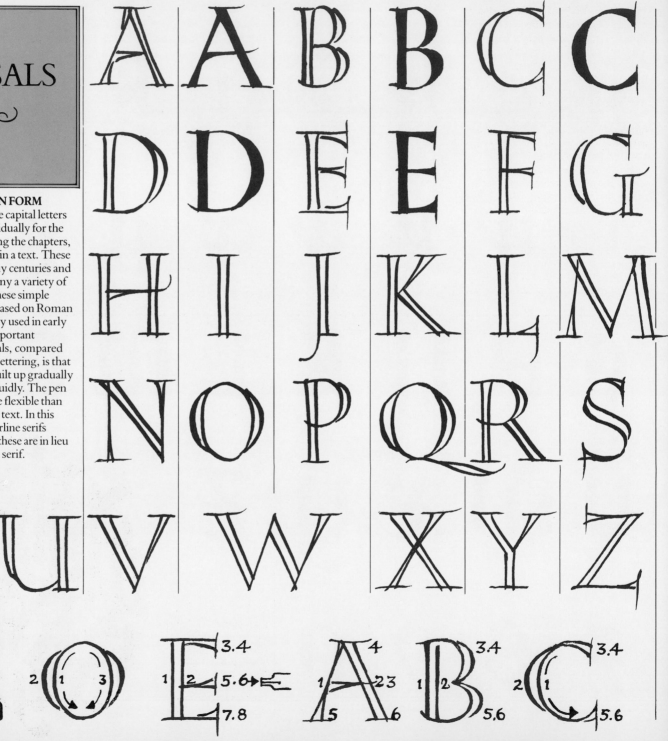

VERSALS – LOMBARDIC FORM

The curving shapes of this versal alphabet are influenced by both Lombardic scripts and uncial letters, as demonstrated particularly in the forms of **D**, **H** and **M**. The cross-strokes and curves are terminated with a flaring of the width cut across by a hairline, and these lines are rather more bold and flourished than in the Roman-style versals, creating a lively textural rhythm. The fine, flexible quill or pen used to draw the versals can be charged with ink or thinned watercolor paint. Two-color versals can be attractively made by drawing the outer strokes in a dark ink and flooding the inner area with color. Red, green and blue were the traditional colors for versals: they are strong hues which balance with black writing ink.

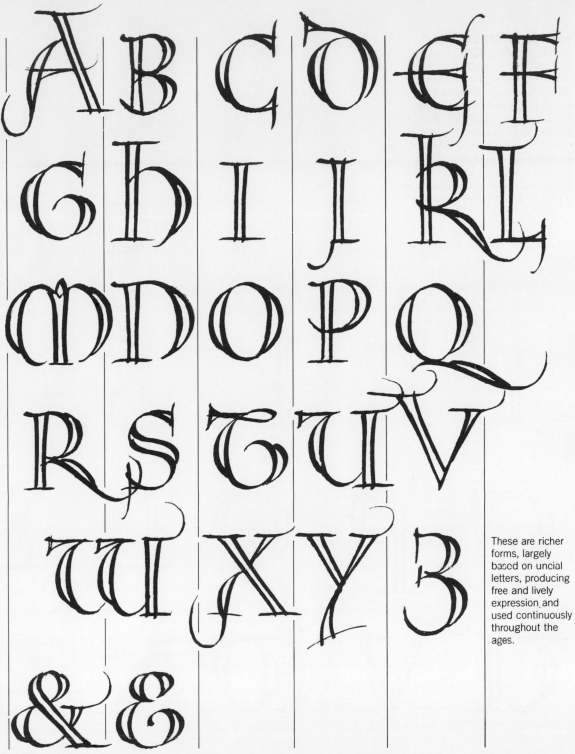

Versals, left, are essentially pen-made with a flexible quill or metal pen. Each versal letter is actually formed with three strokes: a vertical stem, for example, is outlined on each side, and the third stroke is quickly applied to fill the space between.

These are richer forms, largely based on uncial letters, producing free and lively expression and used continuously throughout the ages.

ELABORATED VERSALS

The design of this alphabet takes the rhythmic and flourished quality of the Lombardic style a little further. The construction of the letterforms is very fluid and decorative, from the exaggerated tails of **K**, **Q**, **R** and **X** to the individual details enlivening the counter spaces of **B**, **O** and **Q**. The elaboration is of a consistent style and quality, but intriguingly varied in detail to make the form of each letter not only clearly distinguishable but also individually ornamental.

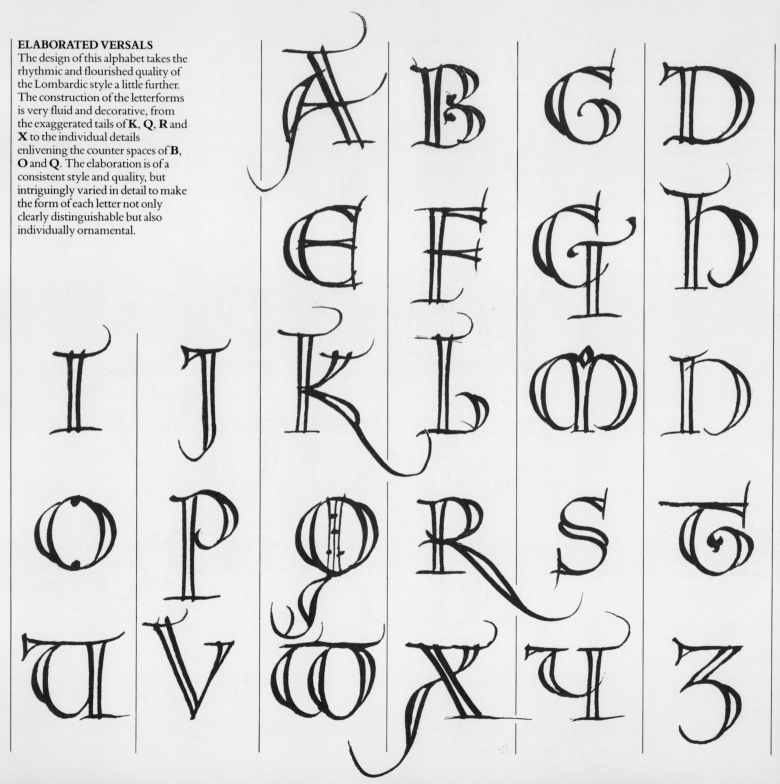

ORNAMENTED VERSALS

The weighty shapes of these Lombardic-style versals are sufficiently broad to allow a decorative piercing of the curves and stems, in addition to flourished and ornamental detail. The drawn versal letter can be the basis of a heavily ornamented or illuminated capital letter, decorated with abstract motifs or, as in the original miniatures of medieval manuscripts, with tiny pictures or figurative images. Colors can be introduced to add variety to the design, and versals are also traditionally the subjects for gilding, with burnished gold leaf or painted powder gold.

BLACK LETTER

BLACK LETTER – TEXTURA

The forms of Gothic script, known as Black Letter, are instantly recognizable from the compressed, angular and vertically stressed letters. The original proportions of Textura were based on three strokes of the pen, so that the counters or interior spaces were the same width as the pen strokes. This regularity can make the combined letterforms very difficult to read as a script. This version shows a slightly more open form with serifs which are naturally contrived in the pen angle at the top of the stroke. The bases of the letters are finished with the characteristic lozenge-shaped feet corresponding to the width and consistent 30° angle of the edged pen. These feet are set slightly off-center on the vertical stems. The form is ornamental and evocative of its period. Development of Black Letter scripts continued through the introduction of printers' types in Europe, and they became the models for the first mechanical letters.

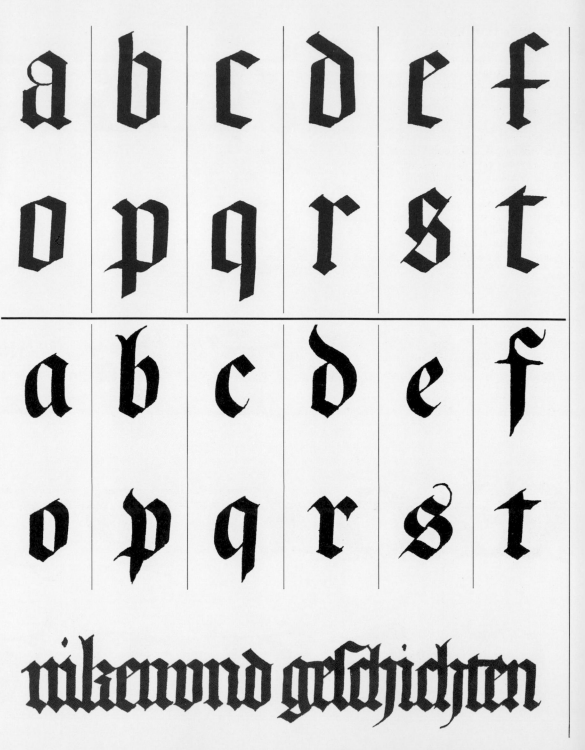

g h i j k l m n
u v w x y z

g h i j k l m n
u v w x y z

mit figuren vnd pildnus

BLACK LETTER – FRAKTUR

Less angular than the Gothic Textura, yet equally characteristic of its time, is the Black Letter script known as Fraktur, identifiable by the torked ascenders. This curious branching of the vertical stroke derived from the cutting of a quill pen with the tip slit to one side rather than centrally, so a slight flick of the pen would create an unevenly broken terminal. This alphabet has the basically vertical, compressed emphasis typical of Gothic lettering, but a more generous width and deliberate curving of certain shapes which relieves the occasional rigidity encountered in the more formally constructed styles.

BLACK LETTER CAPITALS

The gradual evolution of lettering styles meant that at certain times earlier majuscule (capital) forms were combined with minuscule scripts, before a systematized capital alphabet evolved from the script itself. Manuscripts of the early Gothic period frequently employed uncial letters as capitals, and it was also common to use versal letters, sometimes heavily decorated, as initials in a text. Where capital letters were used corresponding to a script, this did not necessarily indicate the construction of an entire capital letter alphabet, but this modern version is based on authentic historical samples and develops the letter structures in the style of Textura script and in logical relation one to another. The capitals are less rigid in construction than the Textura minuscules, but equally decorative and heavily wrought.

Capitals used in Gothic manuscript were versals or more elaborate pen-formed letters. Uncial forms are still in evidence, plus extra strokes, as in **C, E** and **O**.

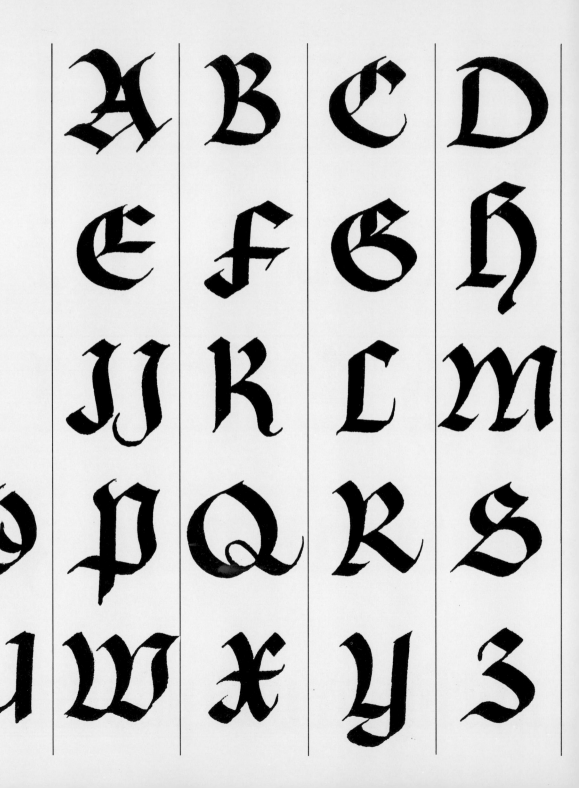

FRENCH GOTHIC

This Gothic alphabet was written into a fifteenth-century French manuscript of prayers and devotions, as if to provide a type of sampler setting out individually the characters of the script used to write the main text. The full manuscript is also richly illuminated with large capital letters and blocks of ornamentation. The letters have a more rounded and truncated style than the earlier Textura script, but this is contrived with a simple elegance. Alternative forms of various letters are included, along with some samples that are slightly flourished. The alphabet begins with the capital **A**, which in Gothic scripts is usually an anomaly in the design, because the triangular construction does not readily adapt to the grid-like system of letter construction.

SIMPLE BLACK LETTER

These tall, narrow Gothic letters were constructed by the German artist Albrecht Dürer (1471–1528). The precision of form in his painting and drawing indicates the discipline of his working methods, here taken to a mathematical extreme in the strict proportioning of a Black Letter alphabet. The grid diagrams show how carefully and accurately each letter is worked out, the elongated vertical stresses giving rise to narrow counter spaces actually less than the width of the pen stroke. As usual in Gothic forms, the **s** has a complex construction required by angularizing of the double curve, and this is more clearly defined by the linear diagram. The diagrammatic approach also demonstrates the placement of the lozenge-shaped serifs at top and bottom of the strokes. The narrowness, height and perfectly regular proportions give a pleasing character and consistency to the dense black lettering.

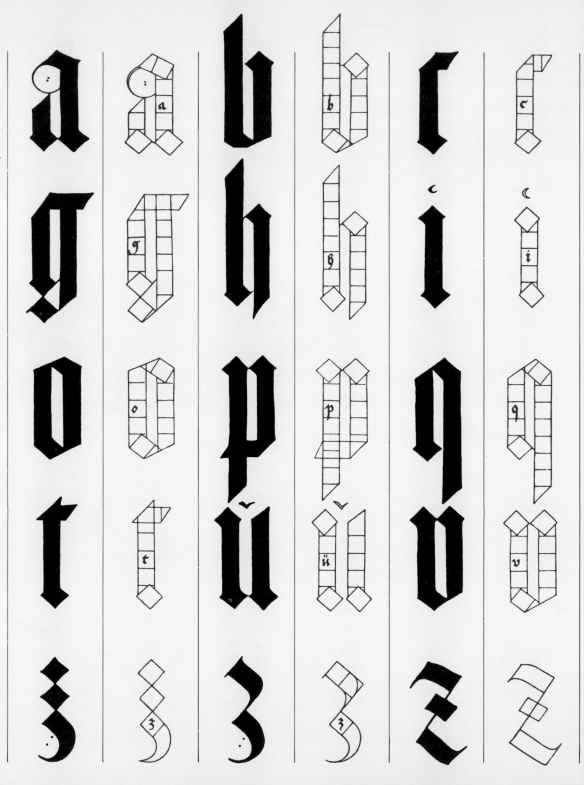

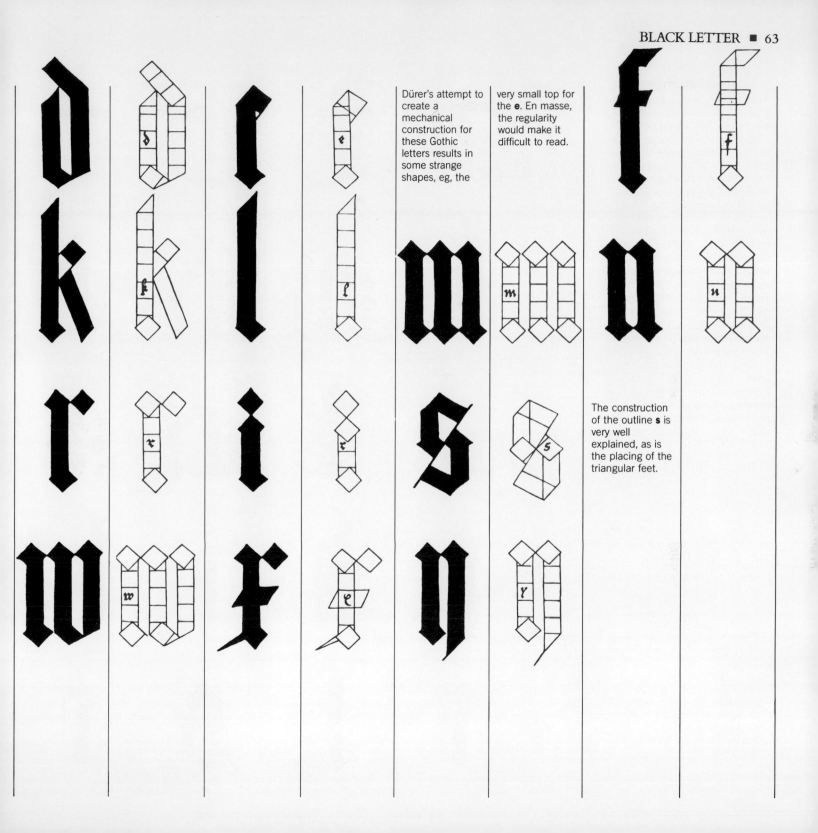

Dürer's attempt to create a mechanical construction for these Gothic letters results in some strange shapes, eg, the very small top for the **e**. En masse, the regularity would make it difficult to read.

The construction of the outline **s** is very well explained, as is the placing of the triangular feet.

FLOURISHED GOTHIC

Another alphabet designed by Albrecht Dürer has a rather more loose and decorative character. Although narrowly proportioned like the previous example, it is more generous in the interior spaces, and the curving flourishes relieve the methodical patterning of the basically vertical emphasis. A form typical of Gothic styling is the single stem of the small **x** crossed by an emphatic horizontal bar, rather than the crossed diagonal strokes common to both earlier and later alphabet styles. The capital letters are more rounded and open than their lower-case counterparts, elaborated with the device of two or three lozenge-shaped ornaments. Dürer carried out many woodcuts and engravings as illustration for printed books, and his interest in letterforms may be seen as relating to both hand-written and mechanically printed texts.

This decorative alphabet has an intriguing, diamond-shaped pattern. Used separately, the letters have an even, modern look.

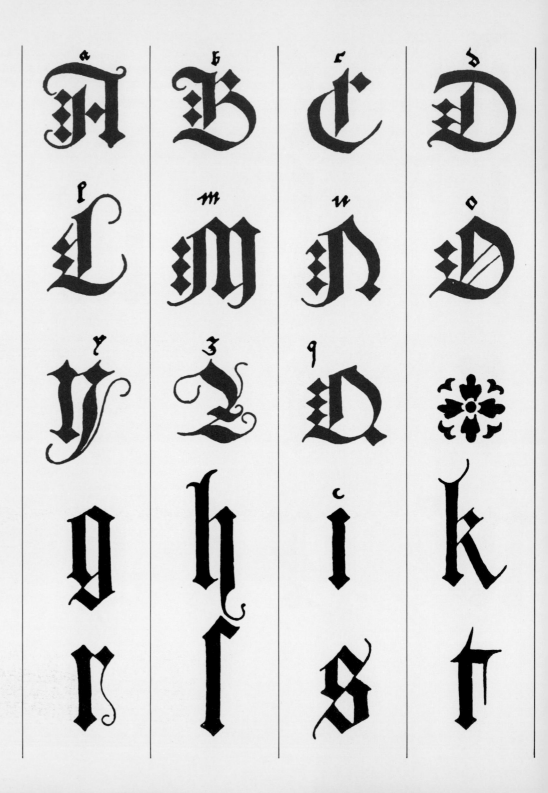

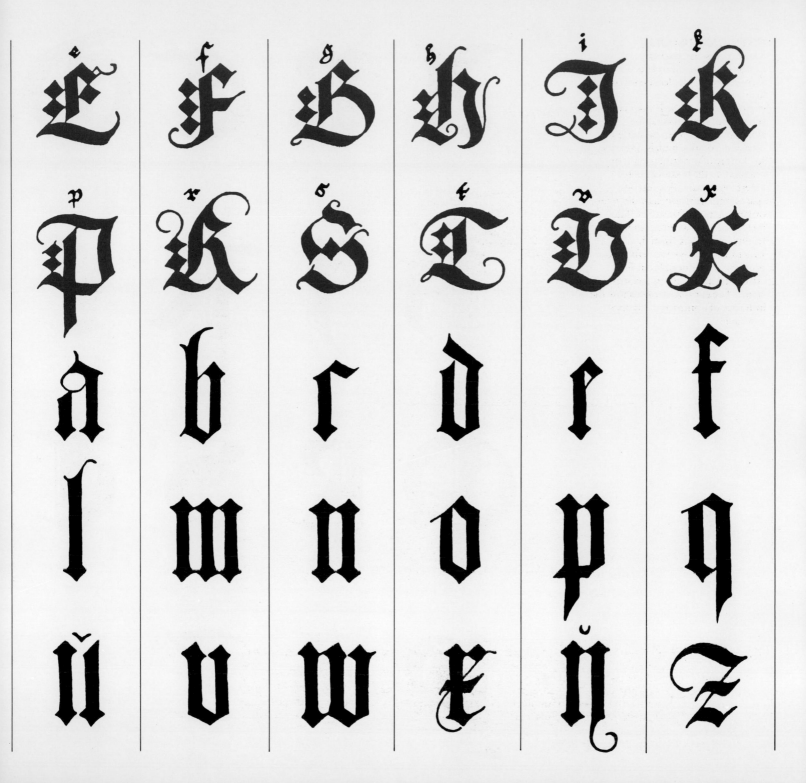

GOTHIC MAJUSCULE
These majuscule letters are noticeably rounded and open in form, texturally far less dense and heavy than other styles corresponding to the Black Letter script. This suggests that the alphabet derives from capital letters used as decorative initials, since the strokes are of medium weight by reference to the body size of the letterforms, providing interior spaces sufficiently open to allow for ornamentation of the form. They include pen-drawn decoration in the features extending from the structural outlines – small flicked protrusions and double hairlines attached to the counters and vertical stems. The curving strokes show the influence of Lombardic and uncial lettering.

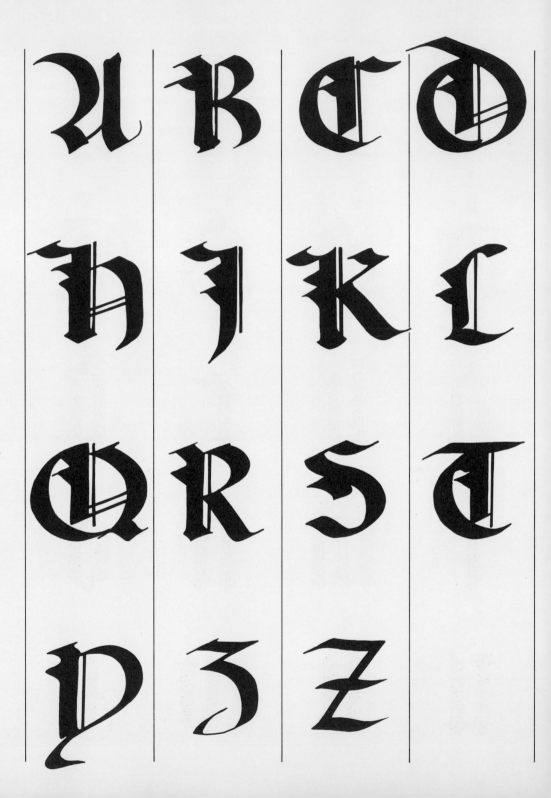

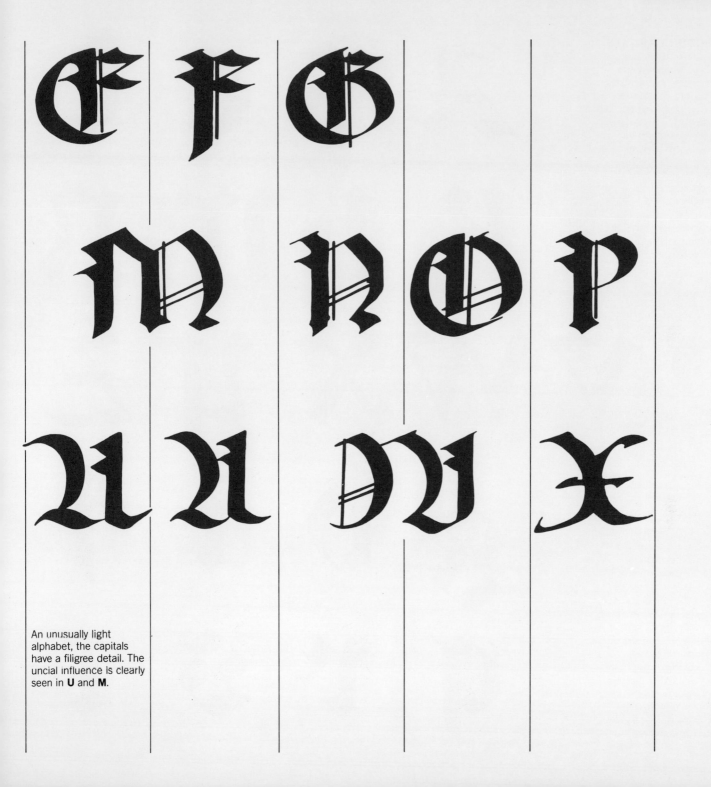

An unusually light alphabet, the capitals have a filigree detail. The uncial influence is clearly seen in **U** and **M**.

MODIFIED GOTHIC CAPITALS

A modern revision of Black Letter styling gives these capital letters a squared and open character with the rich black texture of Gothic but a more pronounced variation between thick and thin strokes. Tiny twists and flourishes of the pen give the curving stems and bowls a lively rhythm. There is some influence from the basic constructions of uncial letters; and although these are relatively simple, broadly described shapes, they have a sophisticated style and consistency derived from the well-judged proportions and the economy of the pen movements.

MODIFIED GOTHIC SCRIPT

A simplified version of a rounded Gothic script corresponds to the capital letters in the sample (above). Here again, the influence of uncial letters is visible in the forms of **d** and **h**, for example, and the compactness of the forms is maintained by the shortened descenders in **p** and **q**. Although a formalized, heavily weighted style, having the typically dense texture of Gothic scripts, this alphabet has a variation in the letter construction that makes it a more distinct and legible script for most readers than the more stylized, angular Textura.

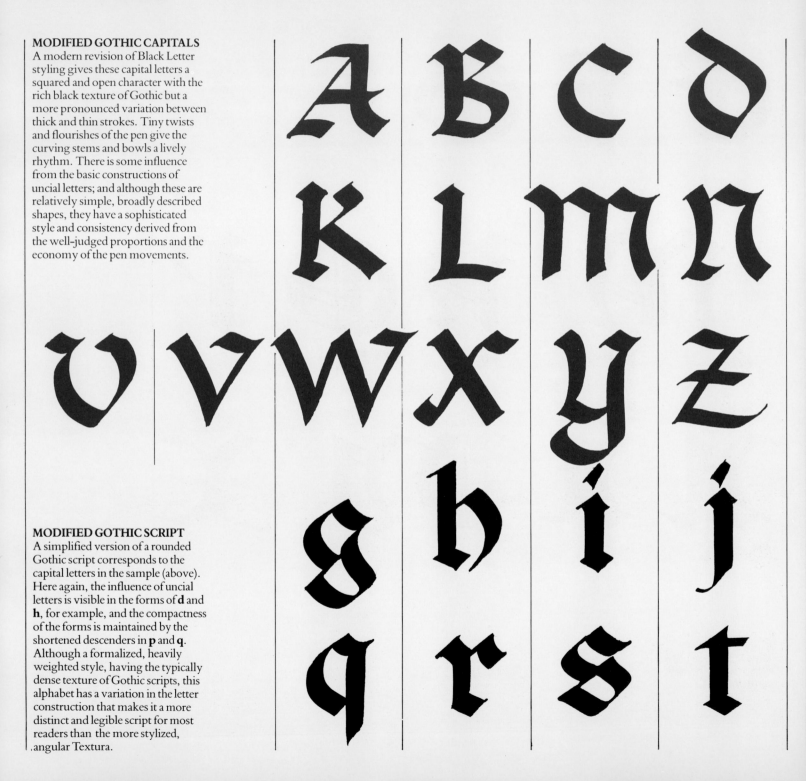

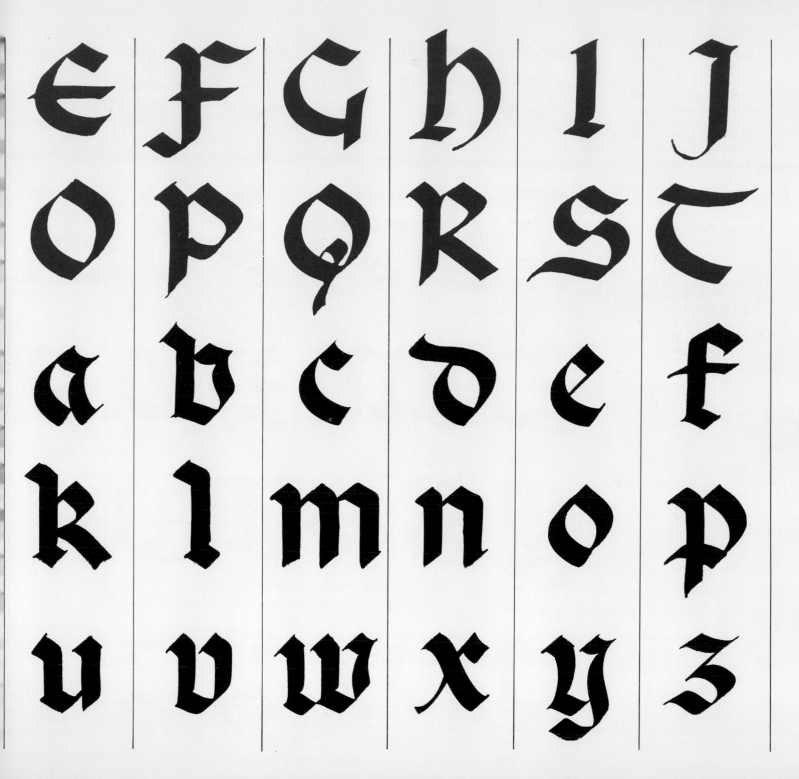

DECORATED GOTHIC CAPITALS

This alphabet is a modern version of capital lettering based on features of Gothic style. Although not an authentic historical form, it is constructed from the elements of the original Black Letter, but with a loosely curving and flourished manner which creates a more elaborate patterning through the forms. The letters are regularly proportioned and designed in logical relation one to another, enlivened by rhythmic motion in the vigorous pen strokes and controlled flourishes. The looping of stems and tails is carried through consistently, adding to the richness of the textural quality. The broken counters of **D, O** and **Q** relate to an ornamental device often seen in illuminated Gothic capitals.

A heavy, decorative Gothic letter with the unusual feature of a base loop, making a rich textural effect.

DECORATED GOTHIC MINUSCULE

Following from the decorated capital letters, the minuscule form corresponding to the previous example shows the same generously curving construction. The elaboration extends into the unusual curling tails and ascenders and the brief, finely flourished loops attached to the vertical stems of certain letters. The generally heavy, even texture of the alphabet is inspired by authentic Black Letter forms, and the characteristics of Gothic script are clearly seen in **m** and **w**, though these are more widely proportioned than is typical in the original style on which they are based.

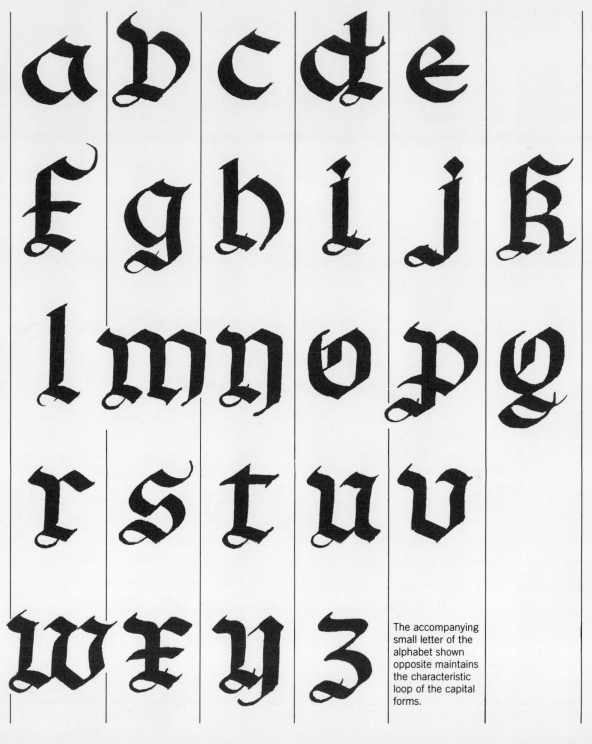

The accompanying small letter of the alphabet shown opposite maintains the characteristic loop of the capital forms.

SKELETON GOTHIC CAPITALS

This modern revision of capital letters loosely based on the style of Gothic Fraktur is written with a double-stroke pen to form an even, open pattern. The double stroke demonstrates clearly the basic form of each letter and the variation between thick and thin occurring naturally in the pen strokes according to the direction of the pen. In this case, the thick/thin modulation appears as a transition from a double to a single line. Fraktur has a spiky, ragged quality echoed in the pointed tails and terminals of these letters. The Gothic origin of the style is particularly apparent in the heavily bowed **T** and the horizontal crossbar of **X**. The curling elaboration of the forms is appropriately applied, and despite the patterned quality of the design each letter retains its recognizable identity.

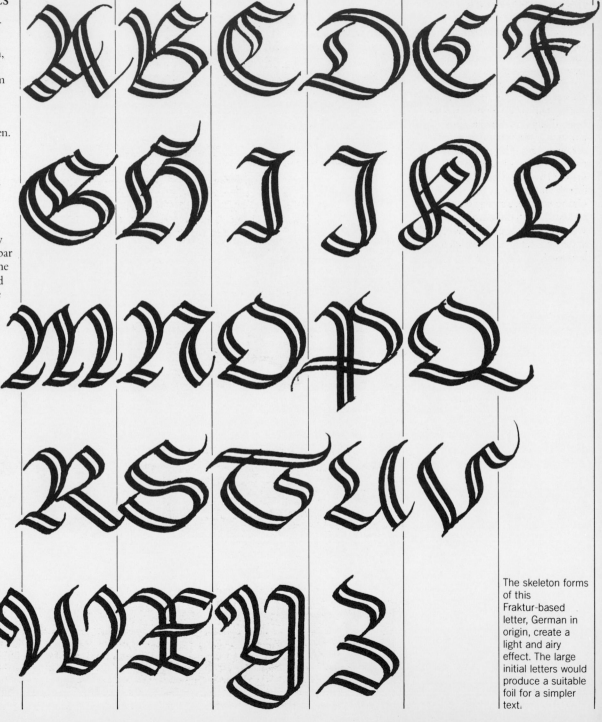

The skeleton forms of this Fraktur-based letter, German in origin, create a light and airy effect. The large initial letters would produce a suitable foil for a simpler text.

SKELETON GOTHIC MINUSCULE

Script letters form the bulk of a text and are characteristically less elaborate than their capital counterparts because of the need for legibility. In these minuscules the termination of the strokes is relatively abrupt; the tails and ascenders, as in **d** and **g**, minimally flourished. Outlining of the form relieves the heavy textural density that is typically a feature of Gothic lettering. Though the letters, composed mainly of straight strokes, still have a degree of angularity, the overall design is broad and open, the counters generously rounded. This feature is typical of later Gothic scripts, in the forms known as Bastarda and Rotunda.

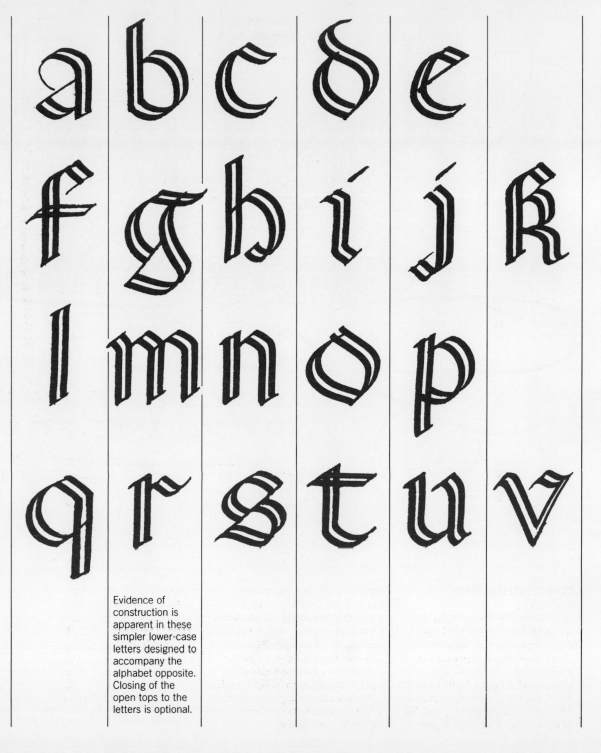

Evidence of construction is apparent in these simpler lower-case letters designed to accompany the alphabet opposite. Closing of the open tops to the letters is optional.

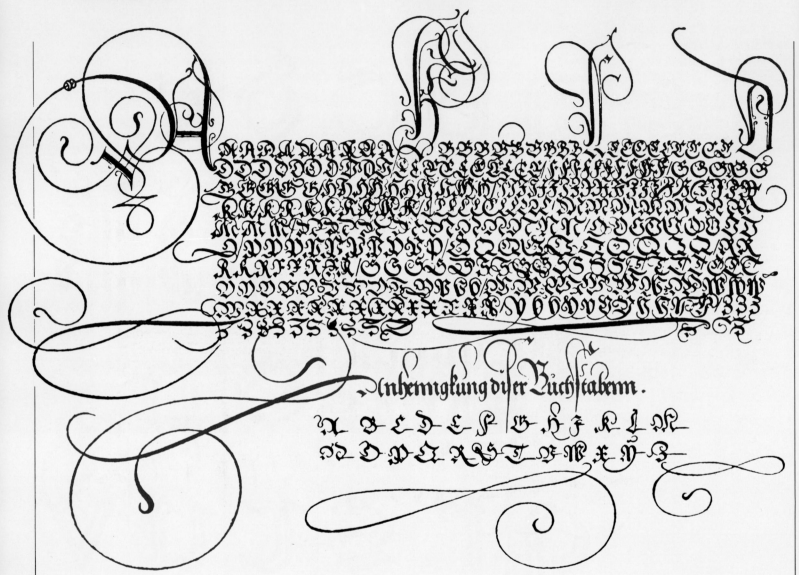

FLOURISHED GOTHIC CAPITALS

A Swiss writing master of the sixteenth century produced this finely drawn interpretation of Gothic capitals, densely packed to form a block of richly baroque texture and elaborated with loops and flourishes woven through and around the letters. Writing samples of this type have more to do with virtuoso pen work than with function and legibility, but it is interesting to trace the usually heavy Gothic forms when they are revised into a finer and more fluid pattern. The ornamentation applied to the capital letters, however, is not carried through in the script sample accompanying the alphabet block, which is restrained and readily legible by comparison.

This richly patterned alphabet is emphasized by repetition of letters and its placing on the page.

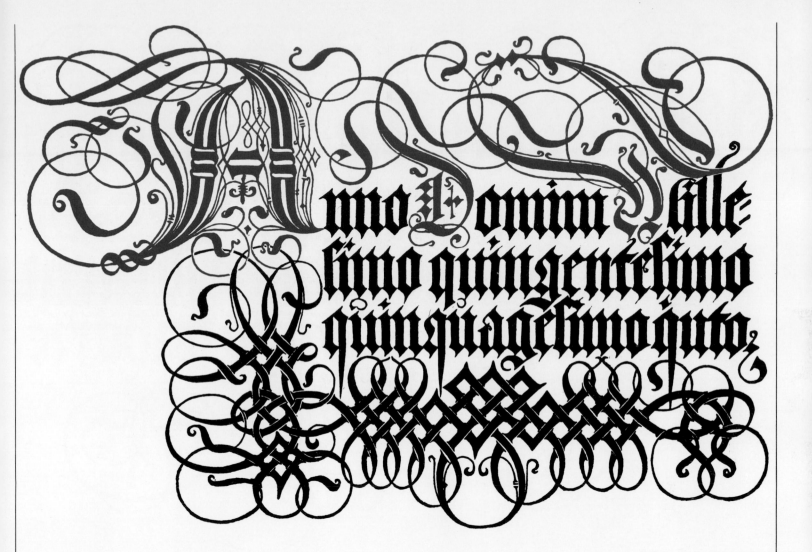

ORNAMENTED GOTHIC SCRIPT

A sixteenth-century sample of Gothic script by the Swiss writing master Urban Weyss (fl 1548) returns to the regular vertical stresses of Textura. The letterforms are of simple and regular construction, but with twisting, pointed terminals more typical of later Gothic style. These create a ragged, angled counterpoint in the rich black texture of the letters. The sample is heavily ornamented with interlocking ribbons and arabesques. These match the text for weight and density but develop freely into fine loops and curls, an unexpected but effective contrast against the angularity of the letters. The combination is contrived in terms of an overall design with balanced internal spaces. The tapering tail of **q** repeated three times in the bottom line of text is an elegant linking device.

Note the pointed finial (as in Gothic architecture) and the pointed feet. The style is richly patterned, the letterform simple, but legibility is difficult.

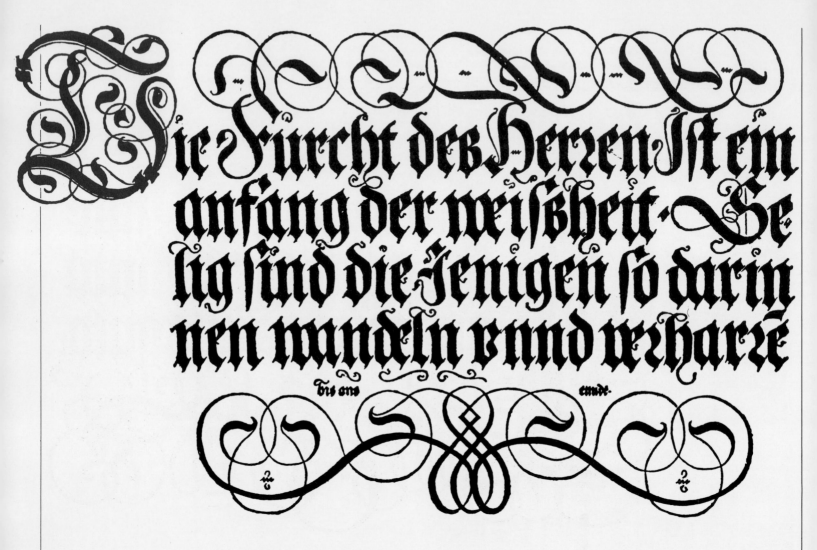

FLOURISHED GOTHIC SCRIPT

Tiny curling flourishes create an effect of fine tendrils escaping from the more solid forms of this slightly rounded Black Letter script. The repetitive vertical emphasis is controlled by the spacing of the letters, although occasional ligatures complicate the pattern of the words. The serifs are based on the lozenge-shaped form first developed in Textura script, but a deliberate twist of the pen curves the lozenge into fine hairline points at each end, instead of the simple blocked shape corresponding to pen width seen in the earlier style. The ornamental devices bordering the text are generally kept separate from the letters, which are linked only briefly by the rising strokes in the top line.

This alphabet is more legible than the previous one, because the letters are not quite so closely joined. The flourished decoration is comparatively simple, but the pointed feet are rather mannered.

ELONGATED BLACK LETTER

This intriguing woodcut version of an elongated Black Letter script originated in sixteenth-century Italy, although the perpendicular Gothic lettering was more widely and consistently used in northern Europe. Here the branching ascenders of Fraktur are developed into a tracery ornamentation of the alphabet, linked also by branched descenders and extended terminals.

A curious device, perhaps inspired more by the technique of woodcut printing than by penmanship, is the way the cross bars of **f** and **t** appear to pierce through the vertical stems. This also occurs where the bowl of **p** returns to the main vertical stroke. The scrolled curls arising from some of the slanted strokes and letter bases are also purely decorative in intent and are not natural pen forms.

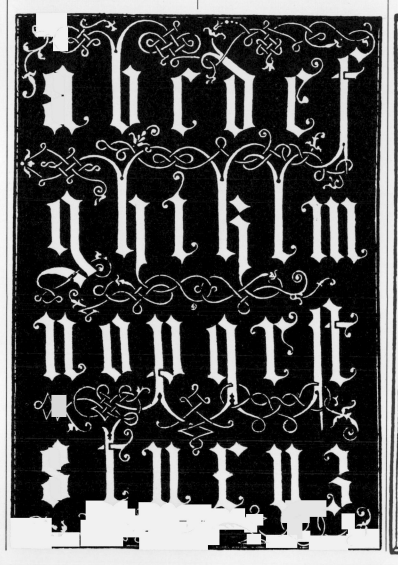

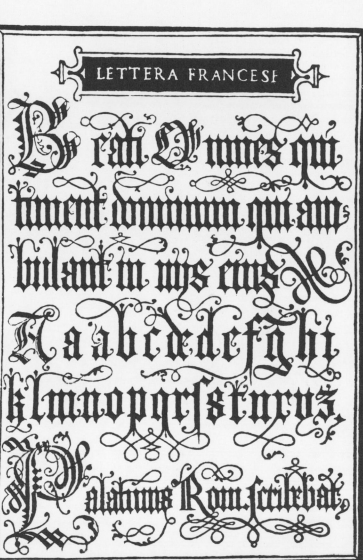

FINE BASTARDA CAPITALS

These extremely linear capitals are barely recognizable as related to the early Black Letter forms but Bastarda, the term given to later Gothic scripts, is typified by a combination of characteristics and often has a generally more rounded and flowing quality. The fineness of the strokes and elaboration of curves in this version of capital letters by Johann Neudorffer partially disrupt the legibility of the letters. But it is an indisputably calligraphic interpretation, pointing the way toward the linear ornamentation of later copperplate scripts. The lettering sample is engraved, but derives from writing executed with a narrow-tipped pen. The broken texture of the strokes is due to the method of printing employed by Neudorffer. The letters were engraved on a copper plate the right way around, so that when printed they became reversed. Therefore a transfer was made from the first printing to a second sheet of paper to return the letters to their proper character. This double-transfer printing has the inevitable effect of reducing the clarity of the image.

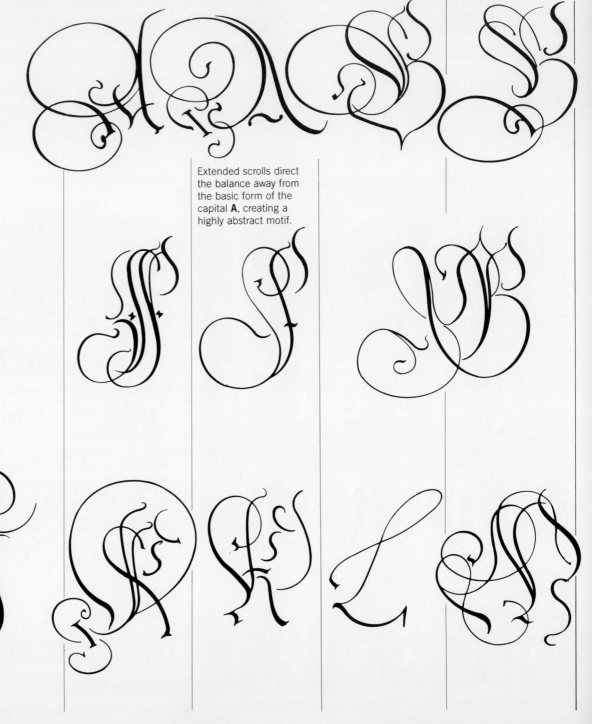

Extended scrolls direct the balance away from the basic form of the capital **A**, creating a highly abstract motif.

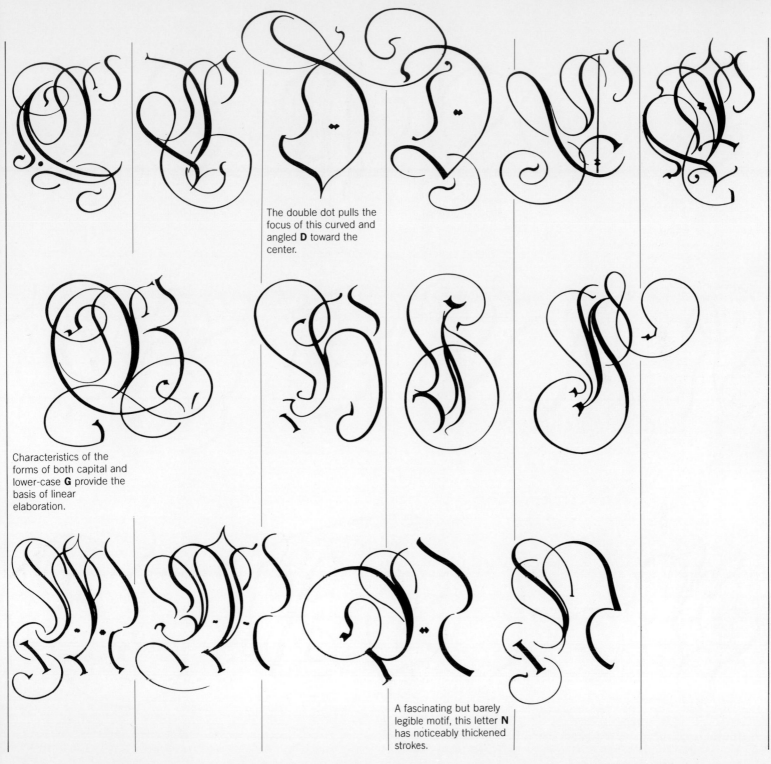

The double dot pulls the focus of this curved and angled **D** toward the center.

Characteristics of the forms of both capital and lower-case **G** provide the basis of linear elaboration.

A fascinating but barely legible motif, this letter **N** has noticeably thickened strokes.

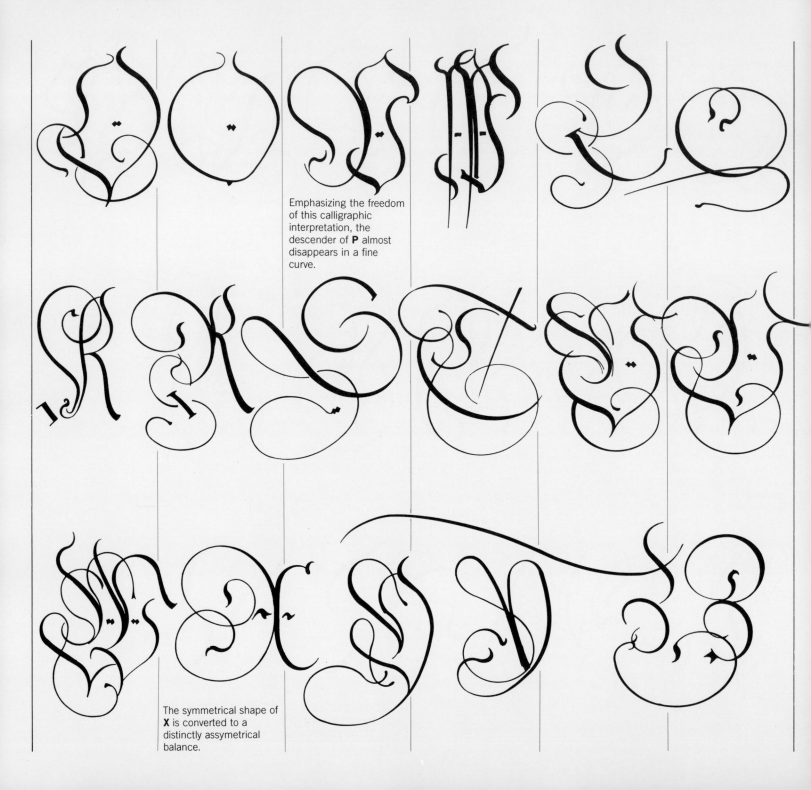

Emphasizing the freedom of this calligraphic interpretation, the descender of **P** almost disappears in a fine curve.

The symmetrical shape of **X** is converted to a distinctly assymetrical balance.

Sípor cruz tormento

ypena Entra ensugloría el

señor como quiere elpecador

irpordescanso ala agena g,

g teaprouecha que sepas

muchas cossas. síno tesabes

saluar. g teaprouecha

que posseas todo el Mundo sítualma

A sample combining the elaborate, Gothic-influenced Neudorffer capital with an early copperplate script by Spanish calligrapher Morante demonstrates the influence of copperplate technique on the forms of the letters — the tendency toward fine and fluidly swelling strokes as compared to the emphatic thick/thin contrasts of edge pen lettering. From the time when the practical constraints on calligraphy were removed by the use of mechanical printing for most types of publication, calligraphers have applied considerable invention and eclecticism to their work. Even more than those earlier writing masters, modern calligraphers and graphic artists can draw upon a vast range of styles and techniques as the basis for new designs and combinations of letters.

MODIFIED GOTHIC

A version of Gothic lettering by the twentieth–century master calligrapher Rudolf Koch (1874–1931) draws on a variety of diverse influences, including Fraktur and Lombardic scripts and uncial letters. The Lombardic manner of marked transition between thick and thin lines and the heavy swelling in the curves and slanted strokes gives the letters a fluid, elaborate quality. Koch also designed printers' types, and the eclectic nature of this design demonstrates his sensitivity toward balance and proportion in letterforms, which in this case, despite the elaboration of detail, remain solid and distinct.

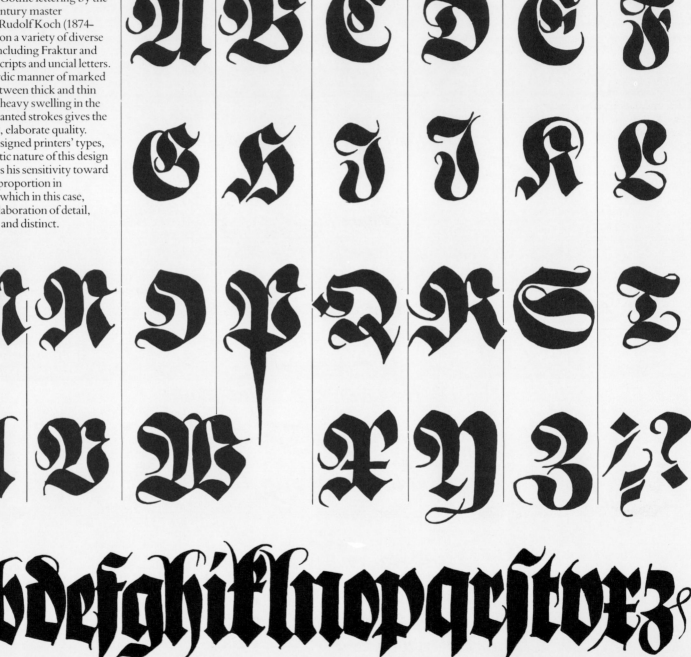

FRAKTUR MAJUSCULE

Like the previous alphabet, these majuscules, designed by Hans Meyer and based on a sixteenth-century Fraktur, show a less pronounced thick/thin variation and a corresponding openness to the letters. Apart from the stem of **P**, there is no obvious vertical stress. The undulating pen movements tend to disguise the basic form of certain letters, and in **Y** the looped extension of the branching stroke makes the character almost unrecognizable but for its place in the alphabet sequence. However, it is this same vigorous fluidity that creates the dancing rhythm of the forms both vertically and horizontally.

MODIFIED BLACK LETTER

The influence of Black Letter persisted long after the late medieval period in which Gothic style matured, and because of its richness it has in successive centuries been favored as an ornamental script. This is an early seventeenth-century example in which the strict vertical emphasis of the stems minimizes the detail of the lower-case letters to a point where the fine right-to-left slanted strokes characteristic of edged-pen letters virtually disappear under the dominance of the thick vertical and left-to-right slanted strokes. These letters are compound forms, combining the quality of marks made by both edged and pointed writing tools, possibly further modified when translated into an engraved sample for publication. The detailed ornamentation woven around the structure of the capital letters has a purely decorative function most fully exploited in the elaborate initial letter accompanying the script sample.

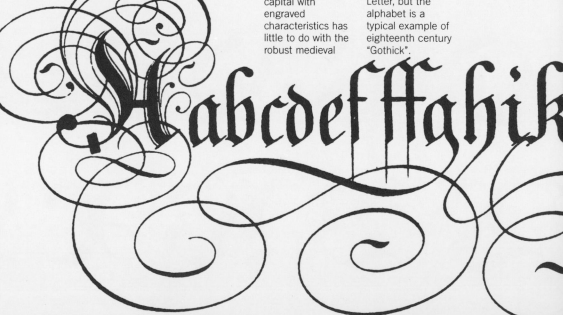

The true nature of Black Letter is somewhat disseminated in this alphabet, but it has interesting decorative possibilities of double strokes, to be adapted with discrimination.

GOTHIC-STYLE SCRIPT

This eighteenth-century script is based on Black Letter, but the open forms, elongated ascenders and flourished tails reflect the fashion of a later period. The Gothic influence appears in the angular arches and pointed serifs, and the alphabet includes the medieval form of the long **S**. The script is of a lightweight, even texture on which the flourishes are grafted with the ornamental line of copperplate writing. Old styles of script recurred in the published works of writing masters more as a demonstration of skill than as an appreciation of the original forms. In the later period of Gothic revival, Black Letter was reworked with increasingly elaborate decoration of the letterforms, which transformed them into drawn motifs rather than written characters.

The finely wrought capital with engraved characteristics has little to do with the robust medieval form of Black Letter, but the alphabet is a typical example of eighteenth century "Gothick".

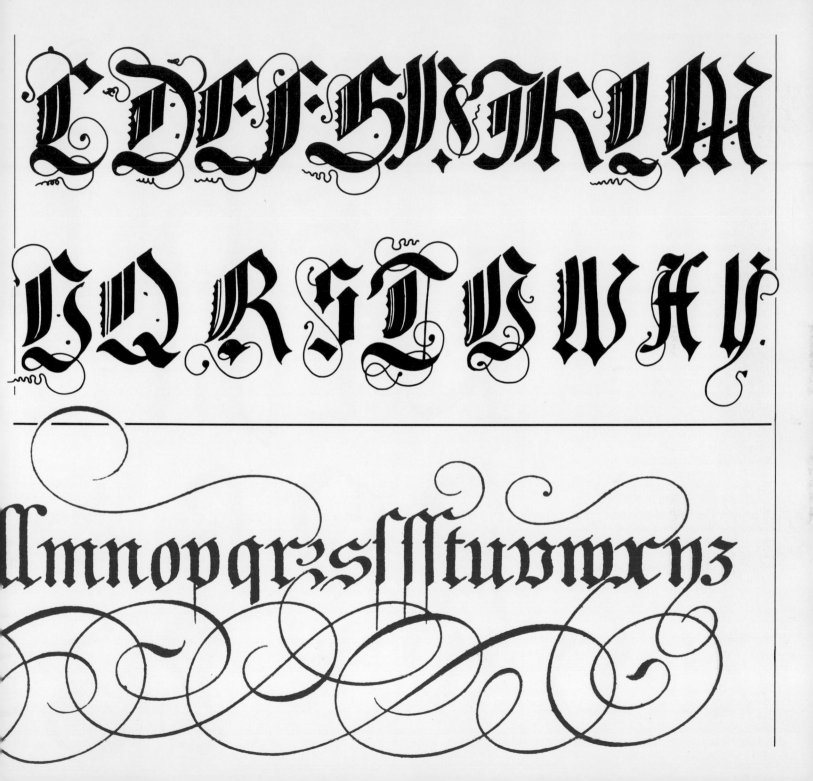

MODIFIED GOTHIC CURSIVE – CAPITALS

The cursive quality in lettering is similar to that of ordinary handwriting. Letterforms are written with a fairly rapid traveling motion rather than the precision and order needed to maintain the more formal styles. This modern alphabet based on Gothic cursive capitals is a highly designed form with a logical structure and proportional system, but the vigor and fluidity of the writing gives the letterforms a delightful spontaneity. Lightly flourished hooks and curves contribute to this quality and indicate the movement of the pen along the writing line. There are elements of italic styling in the branched arches of **M** and the lively points of **W**, but this is an upright rather than slanted form, and the speed of cursive writing is more fully incorporated in the development of compressed and slanted italics.

MODIFIED GOTHIC CURSIVE SCRIPT

A widely influential running hand of the Gothic period was notable for the almond-shaped **O** borrowed from Middle Eastern sources and introduced to Europe following the Crusades. In this modified revision of Gothic cursive script the almond (mandorla) shape influences the construction of all the curved and bowed letters. Compared to the capital alphabet, the script is obliquely written, so that the letters readily become linked when a text is written at speed. The numerals are simply designed with the same fluid, rhythmic quality as the letterforms.

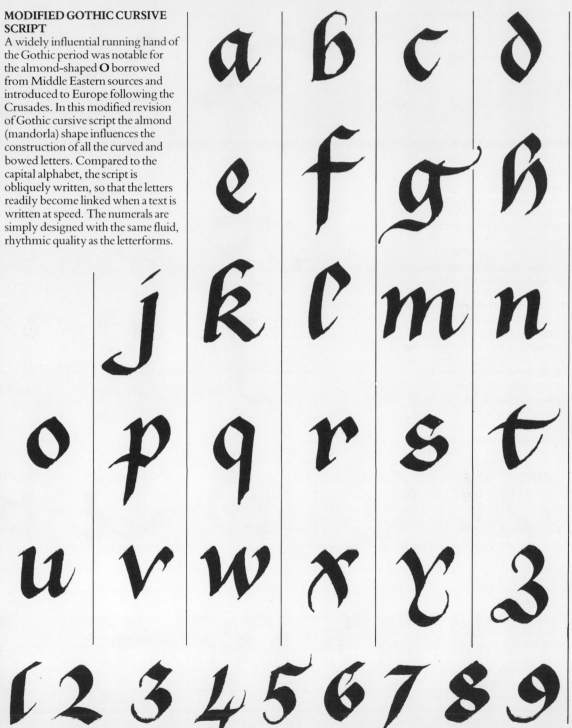

FRENCH GOTHIC CURSIVE

This is an extremely fine sample of Gothic cursive script, a late form of Black Letter featuring rounded and brushing forms enriched by sharply pointed terminals and brief hairline flourishes. It is the work of the sixteenth-century French scholar Geoffrey Tory and demonstrates a casual elegance typical of French Gothic letterforms. The capital letters are generously constructed and vigorously described with a number of decorative variations – the fine hairline cutting through the counter of **O** contrasted with the fluid, heavy vertical breaking into the **Q**; the double curve of **S** and the dual construction of **M**, which has one angular and one rounded arch. The lower-case letters are, as usual, more restrained and evenly textured. The pointed ascenders in **f**, **p** and **q** are characteristic of cursive styles. Certain letters are reminiscent of Fraktur, particularly in the way the broken hairline feet of **h**, **m** and **n** are developed by turning the pen and allowing the tip to splay out from the solidity of the main stroke. The angular bowls and arches increase the ragged, pointed texture of the script.

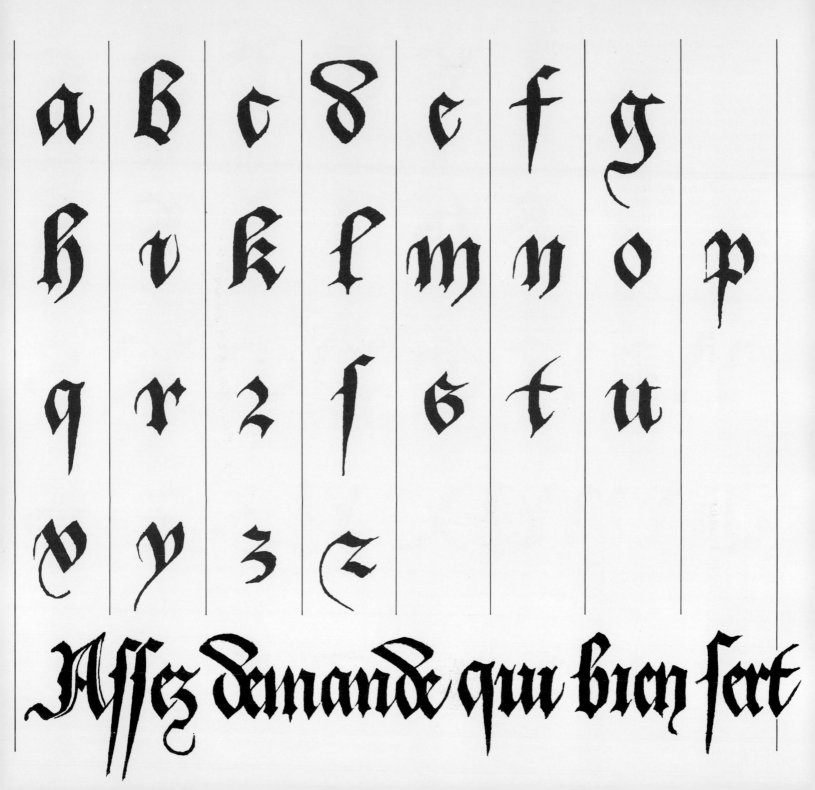

GOTHIC CURSIVE MAJUSCULE

The developments of Gothic letterforms toward cursive styles are categorized as Bastarda (or Bâtarde) hands, sometimes based on the earlier Textura but characteristically more fluid and pointed than the heavily written vertical lettering. This interpretation by Hans Meyer features curving stems and a rhythmic, undulating motion. The letters are of medium weight, relatively broad and open in construction. A decorative feature is the off-center vertical stroke breaking into the counters of the rounded letters.

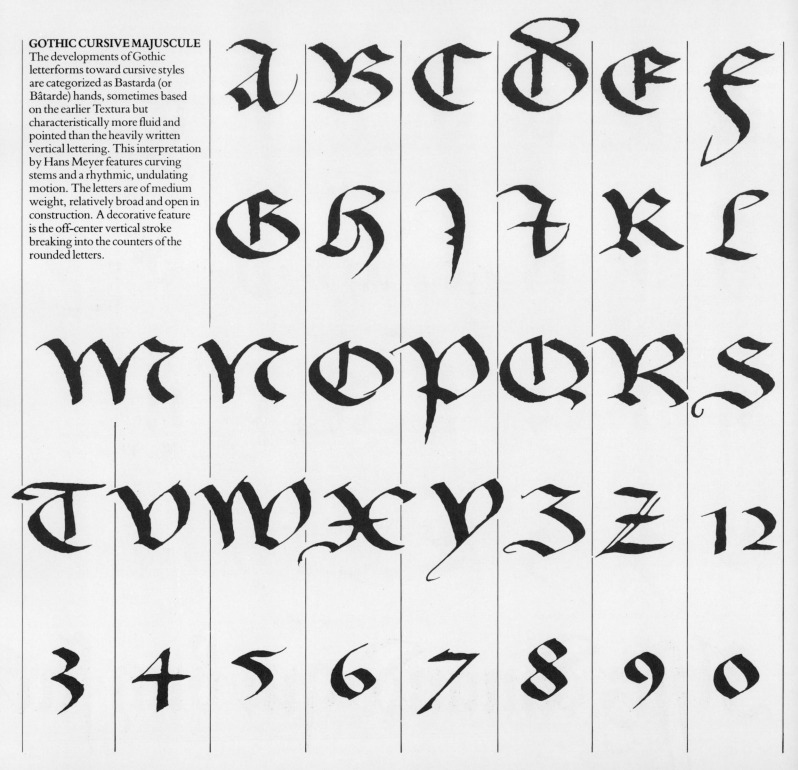

SCRIPTS BASED ON GOTHIC CURSIVE

The rich texture and pattern of Gothic scripts are an ideal starting point for development of freely written, experimental styles of pen lettering. These three scripts by Arthur Baker exploit the exaggerated variation of thick and thin strokes and the pointed terminals of the Gothic cursive. Each alphabet is conceived as a self-contained design with a balanced spatial organization. Every element contributes to the texture and tonal properties – the design of each individual letter, the placing of the alphabet vertically into lines, the letter and line spacing, and the way the block of lettering is set against the surrounding space. The vigorous movements of the broad pen describe successively more compressed forms: the first alphabet (on this page) is generously spaced and curved; the second (on page 92) more closely constructed and characterized by rapid twisting of the strokes: in the third (on page 93), the letterforms become angular, pointed and tightly knit. Whether free or formal, calligraphic forms inevitably reflect the personal touch of the calligrapher, and it is self-evident that these alphabets are written by the same hand. The spontaneity in the work of a practiced calligrapher can be deceptive to the viewer. A design may be written out and modified many times before the result is judged completely successful, and it is part of the skill to maintain the appearance of freshness in the final version.

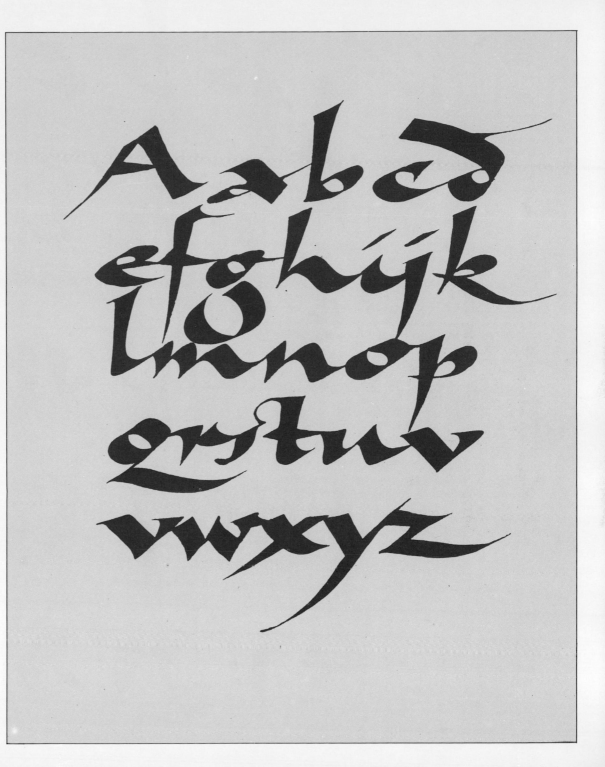

The scripts on page 91, this page and opposite are highly individualized versions by Arthur Baker from a letterform contemporary with the more formal Gothic scripts, and commonly called Gothic cursive, or Bastarda.

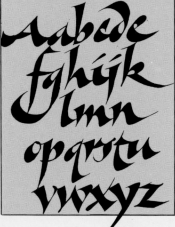

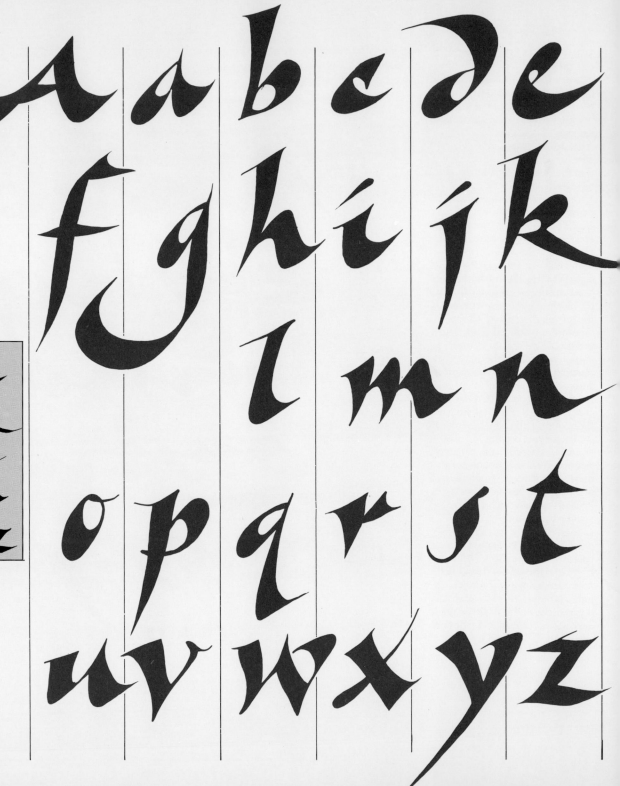

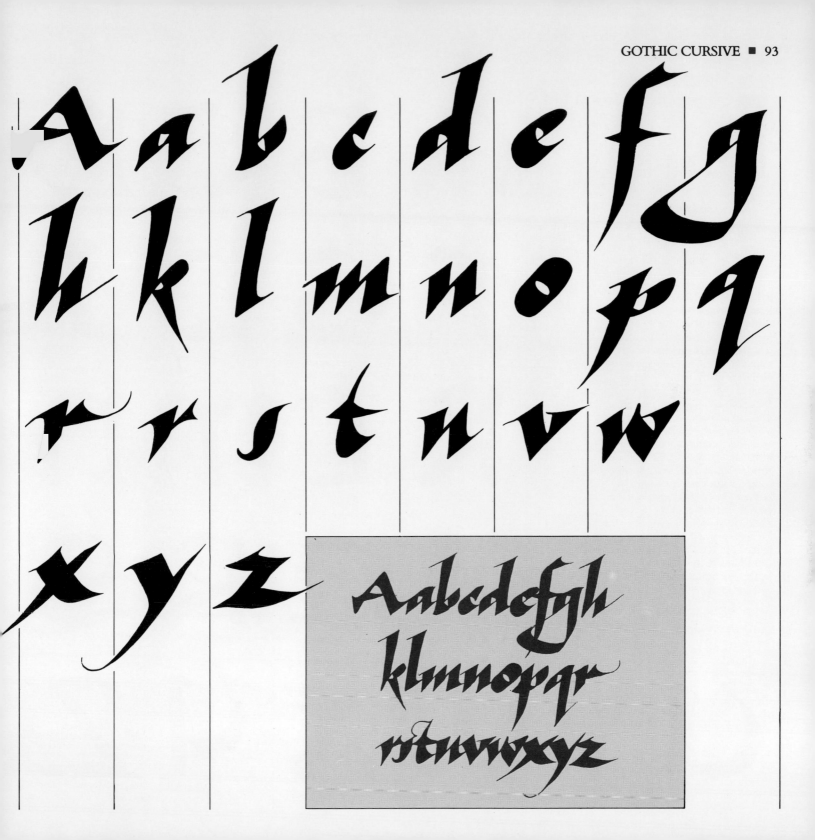

ROTUNDA CAPITALS

Rotunda is the name given to the Gothic scripts of southern Europe, particularly of Italy and Spain, in which the letterforms have a rounded, spacious quality quite distinct from the compressed or pointed styles prevalent in northern European calligraphy of the period. This capital alphabet is based on the traditional features of Rotunda. It is an unfussy, compact form, neatly proportioned with well-modulated strokes. Stems are begun with a simple, natural pen hook and finished cleanly on the angle of the pen nib. Serifs are solidly formed by a horizontal stroke leading from the left at the top of the letter, traveling to the right at the base. This device contributes to the balance of form and texture and also helps to lead the eye along the writing line.

A B C D

F G h I

K L M N

P Q R S

U V W X Y Z

ROTUNDA MINUSCULE

The Rotunda minuscule has a rich, even texture, to modern eyes generally more accessible than the compressed vertical patterning of the earlier Textura script. Its compactness and absence of elaboration or idiosyncratic features give the letters a fresh, open quality useful in formal and informal styles of design. Ascenders open with a very subtle shift of the pen which creates a minimal slanted serif. At the letter bases each stroke is cleanly terminated, as are the descenders, and the tails of **g** and **y** consist of a shallow easy loop. The pen movements that describe the forms are liberal and fluid; the lettering may be used to construct a relatively heavy tone and dense patterning within a text which nonetheless remains not only legible but also pleasant to read.

abcd
efgh
ij

This modified lower-case Rotunda is very legible, with square endings and slightly angled Gothic characteristics.

klmnop
qrstu
vwxyz

A modified majuscule alphabet, the Rotunda, or Round Gothic, was preferred in Italy and Spain to the severe Black Letter. This hand has the richness of Gothic, but maintains the rounder form of the Carolingian minuscule.

SPANISH ROTUNDA MINUSCULE

These letters are remarkable for their confident simplicity – a case of deceptive appearances, since it takes great skill and perception to reduce a form so finely to its essentials. The alphabet is a woodcut version of lettering by Spanish writing master Juan de Yciar (born c 1524). It is rounded and highly formalized, the heaviness of the stroke creating crescent-shaped curves which in **d** and **h** construct forms very similar to those of the early Christian uncial lettering. Yet this is contrasted sharply against the angular structure and delicate hairlines in the letters **a**, **e** and **z**. The balance of the lettering is firmly grounded on the flat bases of the vertical strokes, whereas slanting and curved strokes finish on the angled path of the broad pen tip, suggesting that the writing angle is continuously adjusted to create a precise weight and texture in the letters.

This alphabet shows clearly its woodcut origin. Note the narrow **a** and the uncial **d** and **h**.

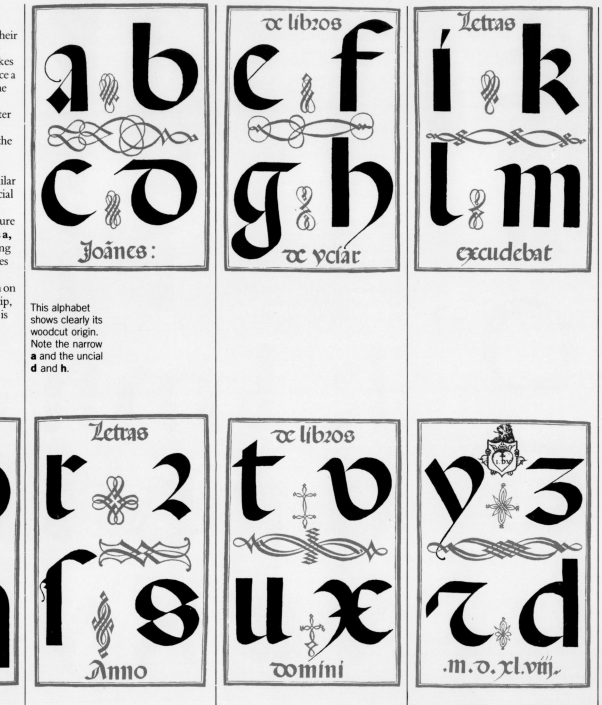

ROCOCO

The strangely curling stems of this alphabet twist the letters into an unusual similarity of construction, as compared to more conventional styles of lettering design, which hold strictly to the precept of a distinct differentiation between straight, angular and rounded letters. The rising plume that forms the stem in **B, D** and **R** is inverted in the hanging flourishes at the top of **K, L** and **P**. The tendency of the forms to revolve upon themselves occasionally interrupts the legibility of the characters, but the contrast between heavily trailed thick strokes and finely flourished hairlines creates a pleasing, fluid texture.

Each letterform in this alphabet, based on a seventeenth-century baroque style, has its own individual detail. The alphabet as a whole is a deliberate illustration of the patterning qualities of calligraphic forms.

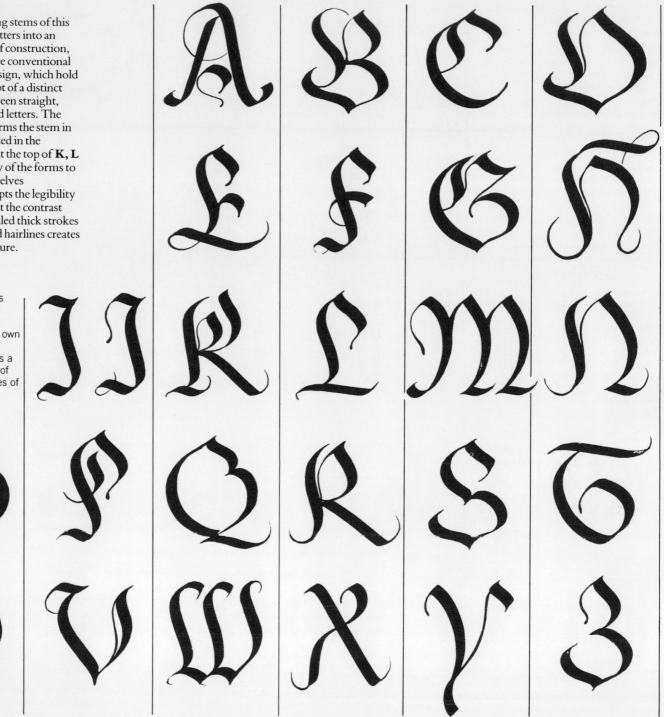

DECORATIVE DOUBLE-STROKE ALPHABET

The double lines of these letterforms are formed by two separate strokes of the pen, and their execution requires confidence and accuracy in repeating the curves and maintaining an even weight and texture. The continuity is achieved by the consistency of the pen angle. But the double-stroke device also offers some slight variations of construction which give the design a lively and personalized touch. Vibrant hooks and curls on the terminals of the strokes also lend an active character to the form. The decorative curling tongues inside the rounded counters of the broader letters are tiny natural pen flourishes.

This two-stroke alphabet is a modified form drawn from a variety of influences. The rounded character of the letters is a mark of Rotunda, and there are also forms borrowed from uncial lettering.

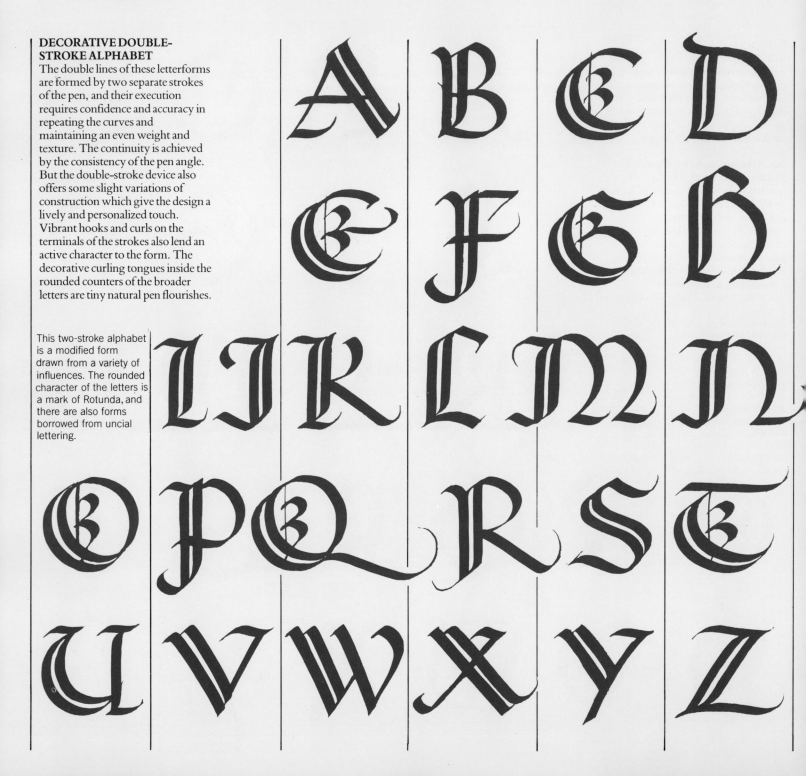

DECORATIVE DOUBLE-STROKE LOWER CASE

In the lower-case alphabet the more compact and curving forms appear more heavily weighted by the strength of the double stroke, since the tightness of angles, bowls and curves forces the pen strokes to create a dense, rich texture. Despite this, it is a balanced and vigorous form, varying in structural detail from the related capital alphabet (see previous sample). Whereas the stem of the capital **F** is a fully double stroke, for example, in the lower-case form it terminates at the cross-bar of the letter; this device is repeated in **i** and **j**, where the double line tucks in halfway down the stem. The hooked and curving horizontal serifs create a sense of motion between the letters, as do the looping tails and descenders.

The accompanying lower case is basically simple in form. The double strokes should begin at one source and end together as one stroke.

ITALICS

**COMPRESSED HAND –
LOWER CASE**

Compressed lettering is a
development from modern
reinterpretations of tenth-century
minuscule letters (see page 50).
These are characteristically elegant,
simple forms, which may be
described as tilted but not
emphatically slanted. The bowed
letters are basically oval rather than
rounded or angular, and this dictates
the lateral compression affecting the
proportions of the other letters.
Ascenders are finished with a natural
pen curve, as are the descenders of
g and **y**, while in **p** and **q** the
dropped stems are neatly terminated
with a sideways twist of the pen.

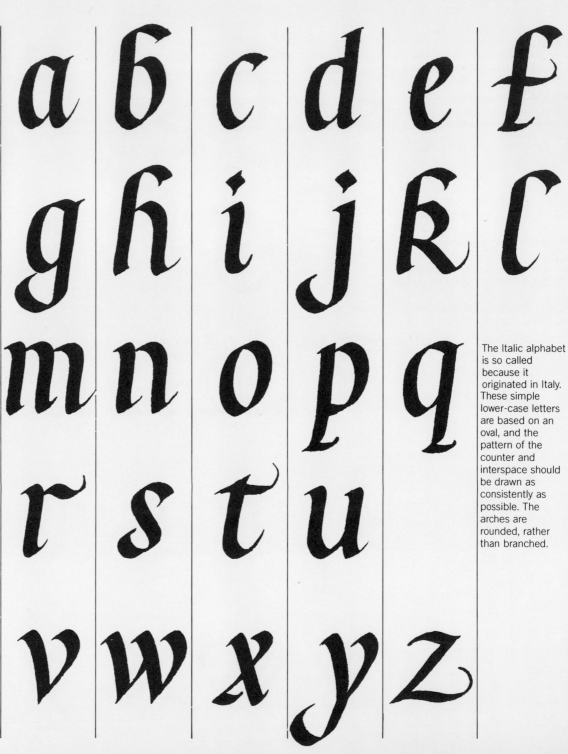

The Italic alphabet
is so called
because it
originated in Italy.
These simple
lower-case letters
are based on an
oval, and the
pattern of the
counter and
interspace should
be drawn as
consistently as
possible. The
arches are
rounded, rather
than branched.

COMPRESSED HAND – CAPITALS

The compressed capital letters are compact forms of medium weight. They have a clean, unelaborated style consistent with the lower-case letters, the same subtle slanting and oval counters being the characteristic qualities. The thick/thin variation of the movement of the edged pen is not particularly pronounced in these letterforms. Vertical and slanted strokes are begun with a slightly angled serif. The bases of the letters are neatly finished with hooked terminals or sturdy horizontal feet.

A B C D E F
G H I J K
M N O P Q
R S T U
V W X Y Z

The capitals in this modern version of the italic alphabet are tall and elegant and work well together. The length of flourishes on tails, etc, is optional.

ITALIC CAPITALS

Notably narrowed and slanted, these letters are a sophisticated modern italic written with a consistent 45° pen angle that creates a fluid modulation in the strokes. Italic capitals are basically a compressed version of the Roman form and have a similar regularity of proportion governing the relationships between the different letters. Flowing extensions of the stems and tails break through the baseline to emphasize the elongated construction. As the squared capitals were the characteristic formal lettering of the Roman Empire, so italic was the typical pen form of scribes and scholars in Renaissance Italy.

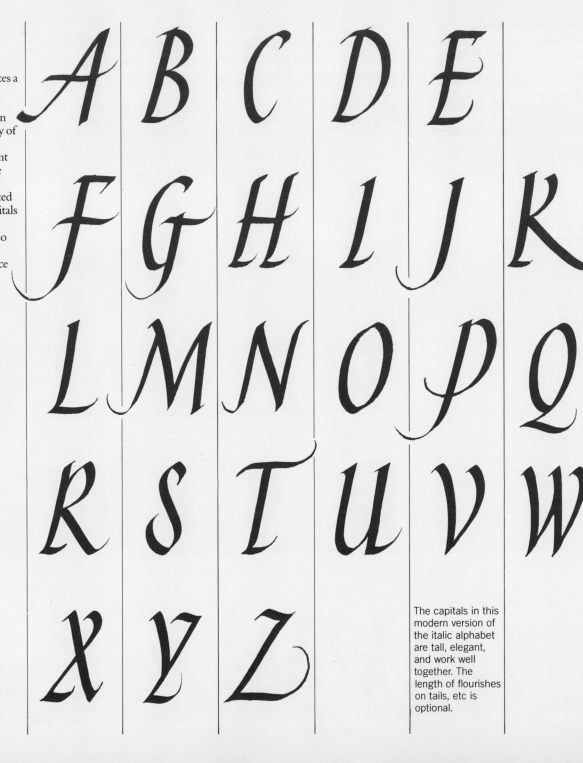

The capitals in this modern version of the italic alphabet are tall, elegant, and work well together. The length of flourishes on tails, etc is optional.

ITALIC LOWER CASE

Italic is a cursive hand, originally developed as a formal script that could be rapidly written without losing the fineness of its proportions and basic structure. In this version of the lower-case italic alphabet, the curved ascenders and flourished descenders give greater emphasis to the slanting of the letters. The extension of these strokes achieves a length slightly exceeding the body height of the letters, but it is not so exaggerated as to destroy the balance in the pattern of the lettering. Apart from the slanting and compression of the letterforms, the main characteristic of italic is the branching of the arches from the main stems in the letters **h**, **m** and **n**. There is a similar construction in the bowls of **b**, **k** and **p**, and this creates the angular nature of italic script.

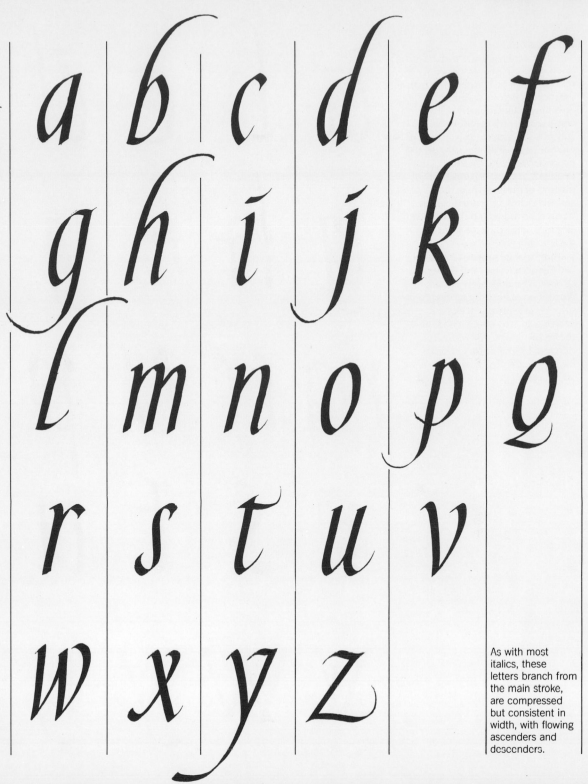

As with most italics, these letters branch from the main stroke, are compressed but consistent in width, with flowing ascenders and descenders.

FINE ITALIC

The delicate weight and texture of this italic sample derives not only from the finer pen line but also from the more generous width and openness in the letters by comparison with the previous compressed, cursive example. The oblique angle of italic is very subtly expressed here and is visible mainly in the tall, curving ascenders. The fineness of the line where the bowls and arches branch from the main stems contributes to the restrained elegance of the form. The flow of the lettering is emphasized by hairline hooked serifs leading into and out of the stems and slanted strokes. The alphabet is a good illustration of how the writing tool imposes a distinctive style on the lettering and, by comparison with the heavier italics, shows the different moods given to similar basic structures by the density of the written texture.

a b c d e f
g h i j k l
m n o p q
r s t u
v w y y z

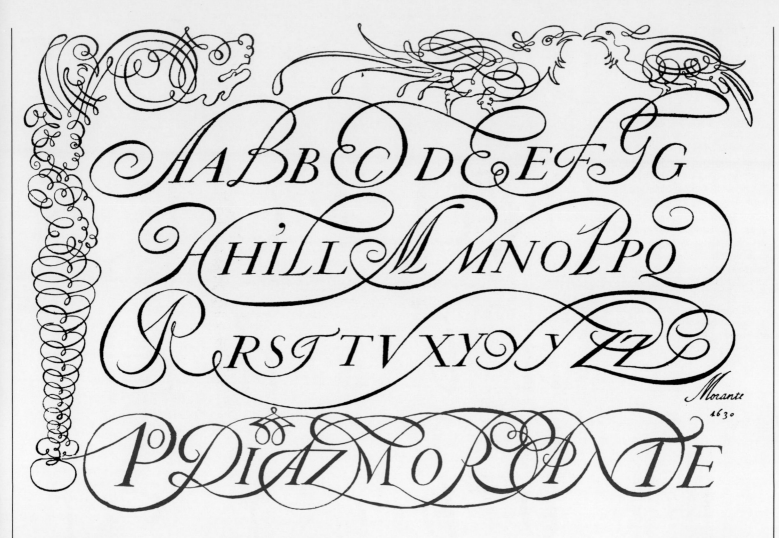

FLOURISHED ITALIC

A decorative italic alphabet by Spanish calligrapher Pedro Diaz Morante (b 1565) shows the coming influence of copperplate style, its controlled loops and arabesques anticipating the more excessive linear ornamentation that in later samples almost overwhelmed the written forms. Two alphabets are woven together here to create the overall design. The more readily legible consists of a broadened italic form still influenced by the thick/thin variation of the edged pen, though the natural pen stroke is modified and the letter stems vary in width. This is framed and embellished by freely written alternative forms of the letters with flourishes flowing back and forth to create a curvilinear framework in which the italic letters are squarely presented. Diaz Morante was a highly influential writing master, celebrated not only for his calligraphic expertise and invention, but also particularly for his speed of writing.

An interesting contrast between the simple, slanted Roman and the flowing, near copperplate capitals, both artfully intertwined in this design.

DECORATIVE HUMANISTIC ITALIC
In the lower-case sample, this alphabet follows the features of a classic italic style, but it is in the capital alphabet that the particular characteristics of the designed form come into their own. The crossed strokes and evenly looped flourishes create a delightful pattern quality, though the letterforms remain distinct and fully functional within this decorative embroidery of the basic shapes. A discreet undulation travels through the assembled forms due to the dropped and extended strokes varying the height and depth of the letters. The movement of the pen through the thick and thin modulations in the stroke endows the basically lightweight forms with a subtle solidity, emphasized in the capitals because the rounded letters are broad and open.

A B C D E F

N O P Q R S

a b c d e f

o p q r s t

1 2

G H I J K L M

T U V W X Y Z

g h i j k l m n

u v w x y z

These capital and lower-case letters are based on a humanistic script of the sixteenth century. They have a delicate flow.

3 4 5 6 7 8 9 0

COPYBOOK ITALIC

The italic and humanist scripts of the Renaissance were widely disseminated through the medium of printed copybooks, the first of which was published in 1522 by Ludovico degli Arrighi (fl 1510–27). This finely textured, even italic is an extremely practical hand, as demonstrated in the text sample, which appears to have been rapidly written without any loss to the elegance of the lettering. It is interesting to note that in the alphabet samples the lower-case letters have a deliberate slant while the capitals alternate different versions, one which is squared and upright in character while the alternative form is compressed, elongated and fluid.

Arrighi was a sixteenth century Italian calligrapher living in Rome. He produced writing manuals and designed type, his italic typefaces being the finest of the period.This is a reprint of his first copybook of 1522, based on the humanist script.

LITERA DA BREVI

A a b c d e e f g g h i k l m n o p q r s f t u x y z

~: Marcus Antonius Casanoua :~.

P ierij vates, laudem. fi opera ifta merentur,
P raxiteli nofrro carmina pauca date.
Non placet hoc; noftri pietas laudanda Coryti eft;
Qui dicat hæc; nifi vos forfan uterq; mouet;
Debetis faltem Dijs carmina, ni quoq3, et iftis
Illa datis. iam nos mollia faxa fumus.

A A B B C C D D E E F G G H H J J
K L L M M N N O P P Q Q R R S
S T T U V V X X Y Z & & B BR

Ludouicus Vicentinus fcribebat Romæ anno
falutis M D XXIII

FLOURISHED ITALIC

Although cursive italic scripts were generally developed in Italy and southern Europe, this particularly exuberant alphabet is the work of the Dutch cartographer and mathematician Gerardus Mercator (1512-94), who in 1540 published a beautifully designed volume of writing samples. It offers a number of variations on the basic forms of the letters, demonstrating long ascenders and flourished tails, and also including the special features of ampersands and ligatured letters. This is a finely written italic with little modulation in the letterstrokes. The controlled vigor of the flourishes insures that they flow naturally from the lettering and do not interfere with the legibility of the characters.

This italic, produced by Gerardus Mercator, the leader of Dutch and Flemish cartographers, is restrained yet exuberant.

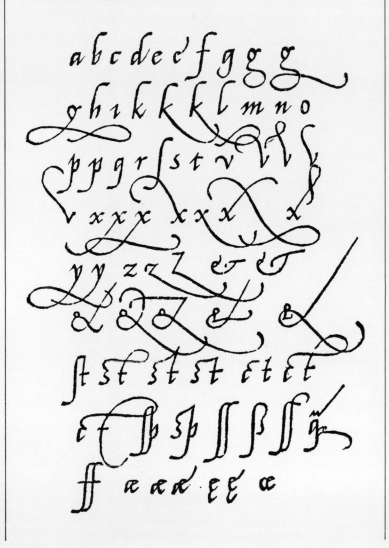

ELABORATED ITALIC

The original manuscript from which this italic lettering sample is taken is an Italian discourse on hawking written around 1560-70. That text occupies the first part of the book and is followed by a number of writing samples. The light-textured capitals with their extended flourishes show the possible variety in the basic letterforms. The final version of **Z** is a particularly curious and decorative construction. The capitals are followed by a script sample containing further elaboration and finely drawn ornamentation. As with earlier forms of lettering, italic became widely used throughout Europe, and during the main period of its prevalence, the style developed differently in different countries and regions.

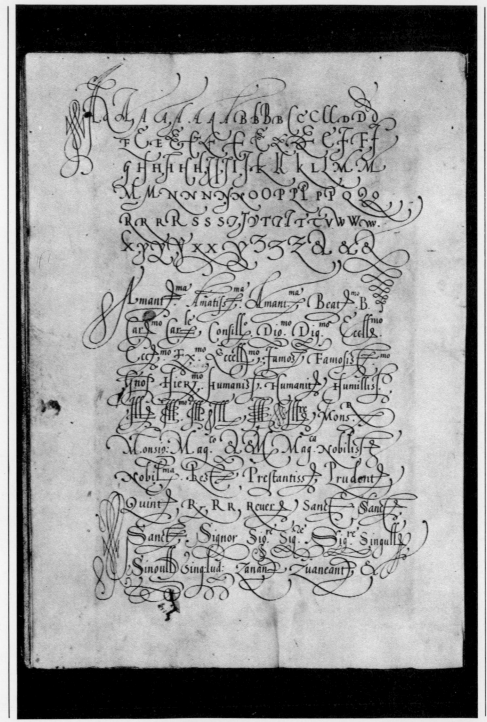

An incredibly rich example of italic capital and lower-case letters. Although heavily flourished, it is an interesting source of invention and inspiration.

SPANISH ITALIC CAPITALS

Francisco Lucas (c 1530 to after 1580) was an important influence on the development of Spanish calligraphy, perfecting his interpretations of the late Gothic cursive Bastarda, the Renaissance humanistic scripts and the rounded minuscules of Rotunda. This sample is a delightful exposition of variations in calligraphic form in an alphabet of capital letters: compact structures contrast with looped and flourished forms. The six different versions of **M** are a particularly descriptive lesson in lettering design.

SPANISH ITALIC SCRIPT

This is a very fine and controlled italic script, with a neat balance between the rising and descending lines and their relationship to the body height of the letters. The letterforms are well-proportioned and evenly textured, the subtle slanting carried through in the tall curved ascenders and clubbed descenders. Distinctive variations of form include the forward and backward facing bowls of the **g**, the straight and curving versions of **j**, the abbreviated **r** and the long and short forms of **s**. The alphabet is reproduced in woodcut, the letters being cut into the ground of the wood block rather than left raised upon the surface, thus printing as white on black.

MODERN ITALIC ALPHABETS

Based on sixteenth-century italic forms, these modern revisions make the most of the sharply branched and tightly compressed patterning of a cursive italic. The first alphabet is closely spaced and heavily weighted by the choice of a broad pen nib which gives emphatic thick/thin modulations and spiky, tapering terminals. The second makes play with fluid, medium-weight letters finely described and even in texture, and with a slightly softened effect. A more radical development of form occurs in the third of these italic samples, where curves are replaced by angles to create an almost rectangular structure to the letter body, which is minimally slanted. Each of these alphabets is a strong and considered design, in the constructions of the letters and their inter-relationships within the lines of writing. Whereas the first two are natural pen forms tracing the passage of the broad nib, the sharpening of the letters in the third suggests that edges and angles have been modified after the initial stroke to describe the particular texture of the finely slanted serifs and filled angles. This is apparent in the width variations in the bowls of **d**, **g** and **q**, where the slight inner curve into the hairline is balanced by a sharp point pushing outward at the base.

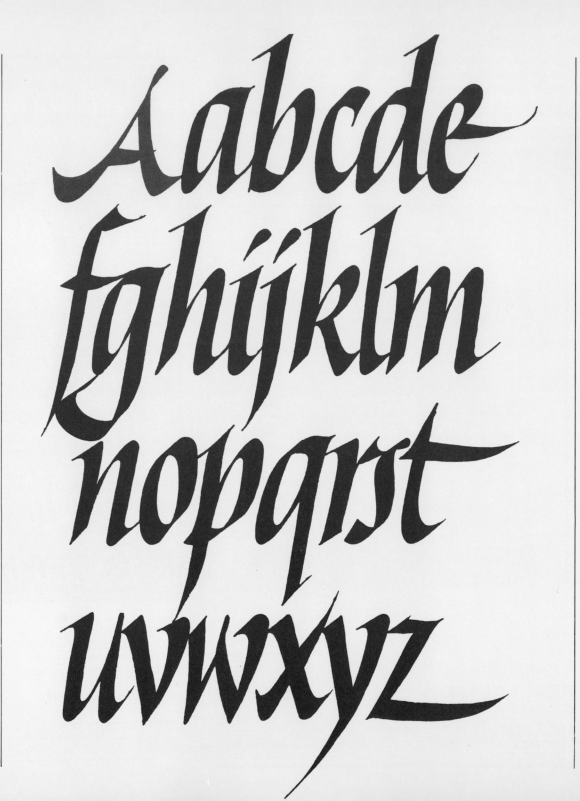

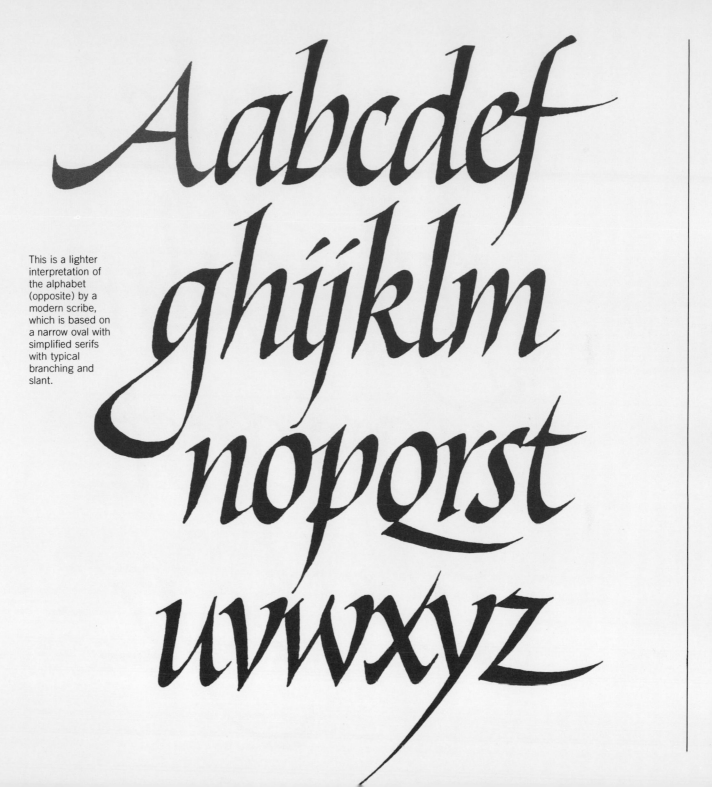

This is a lighter interpretation of the alphabet (opposite) by a modern scribe, which is based on a narrow oval with simplified serifs with typical branching and slant.

The forms of this modern italic alphabet are slightly squared with more angular, pointed letters and a sharper pen angle than the previous sample.

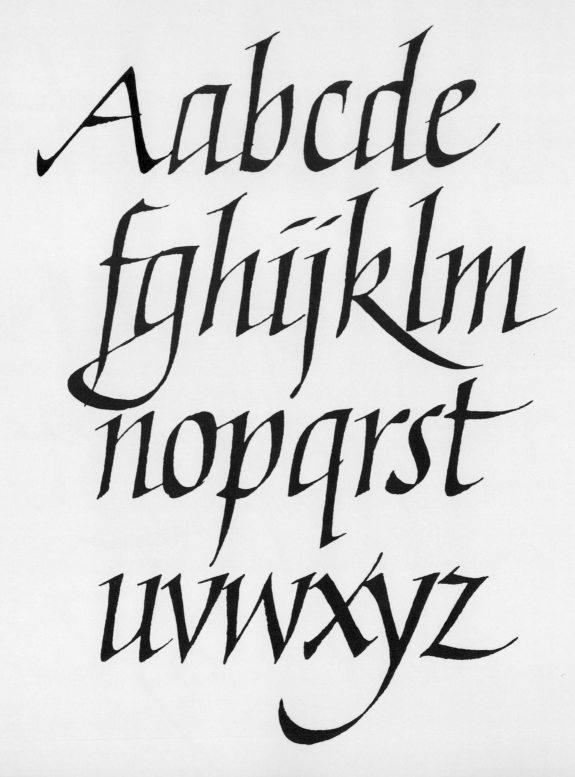

FORMAL ITALIC
This is controlled and stately lettering, having all the characteristics of an italic hand but not well adapted to a rapid or cursive writing method. Even between the different versions of the letters, it is the fluid control of the pen movement that supplies the consistency of texture, the elegance of the line variations and the aptness of the terminals. The letters with upright, serifed stems have a more static quality than those with finely tipped curving ascenders. Unusually, this device is applied also to the alternative versions of the letters, so that while one of the forms is conventional in style, the other is extended and flowing, equally balanced above and below the body height of the letter. The sharply angled oval in the bowls of certain letters gives them an upward pull countering the relatively extended width.

a b c d e e

f g h i j k l

m n o p q r s st

u v w x y z z

HUMANISTIC CURSIVE CAPITALS

Humanistic scripts were originally a southern European development based on the rounded ninth- and tenth-century minuscules. These upright and cursive hands were a product of the Renaissance period in Italy, in their turn giving rise to the compressed and angular italic which is categorized as a humanistic hand. The alternative forms in these cursive capitals reflect both the earlier influence and the development of the style. The slight slant is typical of italic, as are the sharply turned angles of **M** and **N**, in this case incorporating fine, tight loops at the joining of the strokes in the head of each letter. But the letters also include a more fluid, rounded form of construction, still with an italic-style branching of arch from stem but with a clearly defined curve at the top of the letters and generous space between terminals at the base. The device of a leftward, looping flourish from top to bottom of a form helps to balance the spidery, tilted lettering.

Another modern interpretation of a humanistic majuscule alphabet. The fluid, looped forms in **E** and **W** suggest the beginning of early copperplate characteristics.

C D D E E F F G

L M M M N N O P

J J J T T U V Y

Y Y Z

3 4 5 6 7 8 9 0

DECORATIVE ITALIC

This is a sixteenth-century copybook form, another sample in which the sharply elegant slanted italic evolves under the influence of copperplate engraving into a finely flourished, trailed and ornamented style of capitals. As was the usual practice in writing manuals, each letter is given in different versions. In this case these vary from the oblique to the rounded, with decorative features from hooked or curving terminals to scrolled and woven ornamentation. The thick and thin variations of the letter strokes are not pronounced and suggest the original use of a pointed pen, with pressure applied to splay the nib slightly in order to broaden out the fine lines and soften the longer flourishes. The engraved sample was published in England, but shows the influence of Italian writing styles.

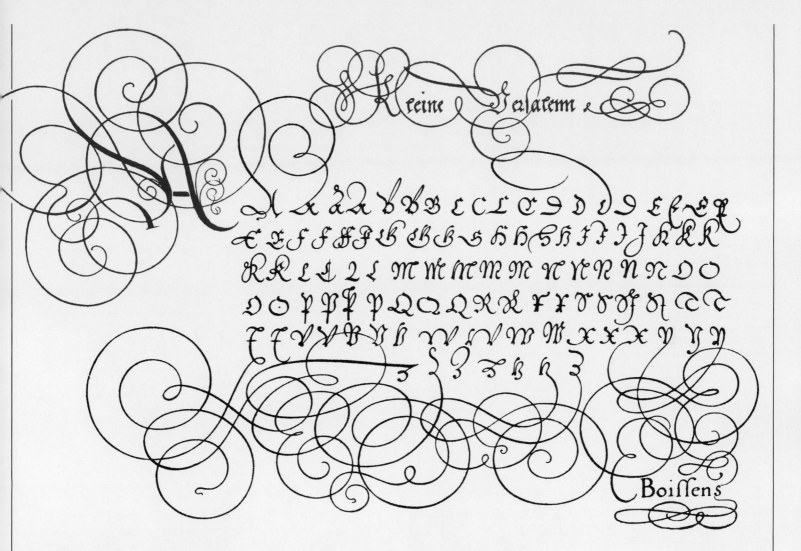

SLANTED GOTHIC

The characteristic slant of italic is here applied to an elaborate style of lettering based on earlier Gothic forms. The sample is from a sixteenth-century Dutch copybook. The letterforms are inventively constructed, with full advantage taken of the fine pen line, which is twisted and looped into curious interpretations of each form. In the more imaginative versions, notably of **B**, **G**, **P** and **S**, the character of the letter is taken so far beyond its recognizable shape and structure that seen out of context it would appear as a decorative abstract motif, calligraphic in influence but not necessarily identifiable as lettering. In designing an alphabet sample it is acceptable to develop these ornamental qualities because the form is identified by its place in the letter sequence, though in a general text they might be less appropriate. This design shows a keen appreciation of line, texture and spatial balance and demonstrates the graphic value and aesthetic pleasure of highly developed calligraphic skill.

A curious mixture of Gothic Fraktur and Baroque letterforms, with copperplate flourishes.

COPPER-PLATE

FLOURISHED CAPITALS

By the end of the sixteenth century, fine engraving on copper plates had superseded the broader printing technique of woodcut as a method of reproducing writing samples for publication. As the solid forms appropriate to woodcut had caused some modification to earlier pen lettering styles, so the fineness and fluidity of copperplate engraving itself began to influence the fashion in writing styles, giving rise to the curling linear forms that became known as copperplate scripts. The delicate swelling and narrowing line made by a graver corresponds to the traveling mark of a pointed pen guided under varying pressure. This impressive sample of copperplate capitals has great movement, style and energy, but it is controlled in the execution to produce harmoniously balanced relationships between the letters.

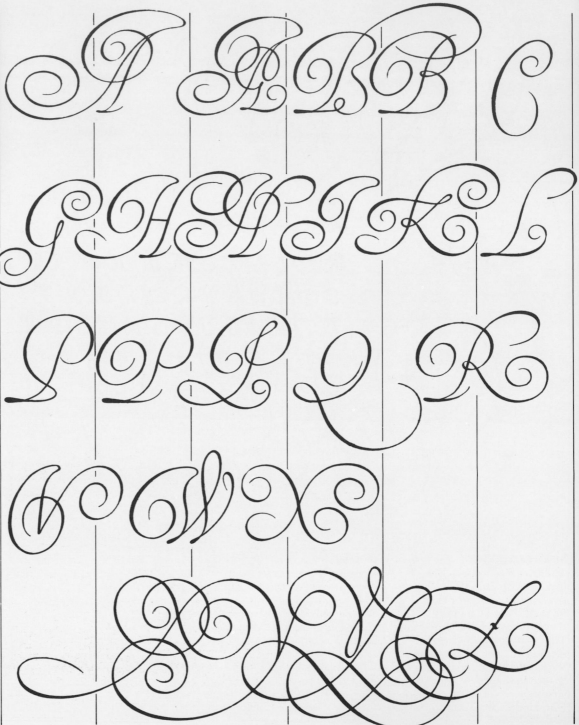

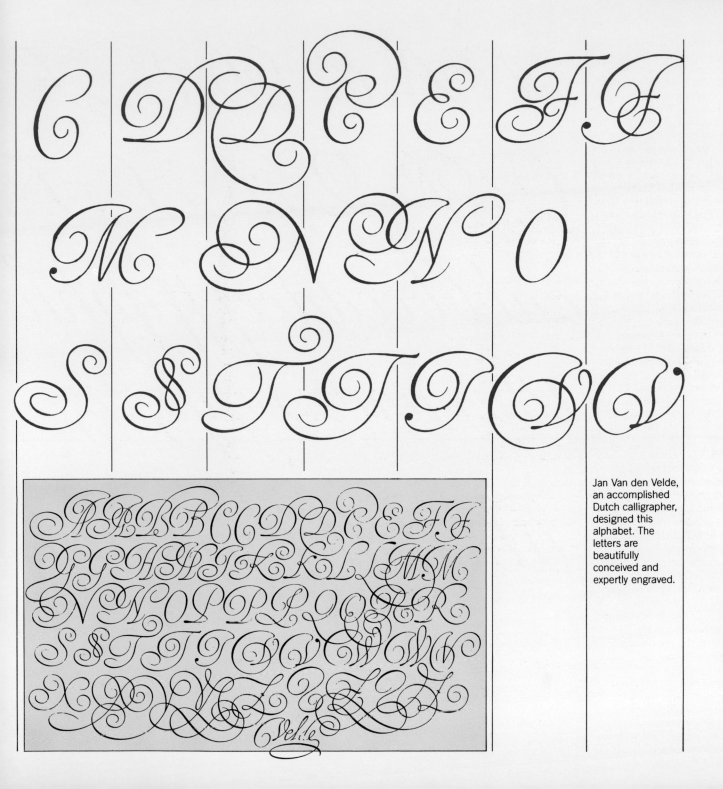

Jan Van den Velde, an accomplished Dutch calligrapher, designed this alphabet. The letters are beautifully conceived and expertly engraved.

ROUND HAND

English copperplate script of the eighteenth century demonstrates a refined and even hand in which the smoothly curving letterforms are slanted and cursive. This is a prime example of lettering designed specifically to be reproduced by engraving. The pointed pen moves fluidly through the form of each letter, and the varying pressure used to modulate the pen line has been subtly applied and carefully controlled. This is a decorative but not elaborate script, the lower-case letters being finely balanced and embellished with loops while the capitals are evenly matched and developed with elegantly restrained flourishes. The engraving, though not the original lettering, was carried out by the English calligrapher and master engraver George Bickham (c 1684–1748), whose collection of writing samples published serially under the title *The Universal Penman* was highly influential on contemporary writing style.

COPPERPLATE SCRIPT

This rather weighty copperplate form, although rolling and cursive in style, is derived from an attempt to subject script lettering to a geometric system of construction. The letters are remarkably even and regular in proportion. The very straight and clean-cut ascenders and descenders are offered as an appropriate contrast to the elegantly curving tails. The relatively emphatic thick/thin modulation of the strokes refers back to the characteristic texture of edged pen writing, but in this case it is artificially constructed by drawing with a pointed pen, outlining and then filling the broader width of stems and curves, as may be seen in the samples of letter construction developed in skeleton form within a carefully constructed grid format.

G H I K L M N

U V W X Y Z

ijkkllllmmnnnoopppqqrrrsfs

n opqrsfsttuvvuxxyyz.

POINTED PEN LETTERS

This is an extremely refined, formal cursive script typical of the development of pointed pen lettering under the influence of copperplate engraving in the eighteenth century. Its elegance derives from the compressed and elongated style. In the lower-case form, the length of ascenders and descenders exceeds the body height of the letters, but the evenness of the proportions maintains the overall balance of the script. The rounded capitals are elaborated with flowing, looped flourishes while the subtly fluid stems of **H**, **I**, **J** and **K** are topped with an intriguing double curve. The numerals, though consistent with the overall style of the lettering, are a little more generous in width but carefully contained within a fixed body height.

A B C D E F

O P Q R S T

1234567890

1234567890

POINTED PEN LETTERS

The lightweight, flowing texture of pointed pen writing has a gracefulness seen at its best when an alphabet form is designed, like this sample, as a series of well-proportioned, unelaborated shapes. The loops and curls are restrained and naturally in harmony with the basic structure of each letter. The cursive nature of the script is demonstrated in the finely slanted joining strokes forming discreet links between the letters. The relationships between the script, capitals and numerals are completely consistent and appropriate, including the alternative rounded and angular forms shown for the capital letters **M**, **N**, **V** and **W**.

A B C D E F

NN O P Q R

This alphabet combines round and pointed capitals with some alternative letters in both styles.

G H I J K L M N

U V W X Y Z

abcdefghijklmnopqrrstuvwxyzzz

G H I J K L M M

S T U V W X Y Z

FINE GOTHIC-STYLE SCRIPT

The fashion for copybooks in the eighteenth century encouraged the most versatile displays of calligraphic skill and the technique of copperplate engraving was not employed solely to reproduce the style of current pointed pen lettering. Whereas the Gothic-influenced script, which the original publication terms "German text," refers to the earlier style of edged-pen letters, the tools of engraving require that a heavy black line be built up from several finely cut lines. This sample shows a modification to the letterforms with regard to the influence of that technique. The lower-case letters are made light in texture and slightly flourished. The tails and ascenders, though complementary, do not extend naturally from the angular, pointed structures but seem to be an addition based on contemporary fashion. The capitals are more heavily defined but decorated with finely looped ornamentation. This balance of texture insures that the letters emerge as distinct and legible despite the elaboration.

The alphabets on these two pages were engraved by George Bickham and show a variety of hands current in the eighteenth century, some still retaining Gothic influences. Sometimes the two styles were combined.

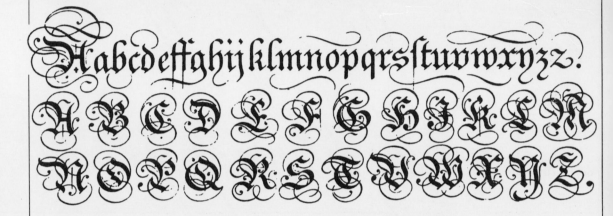

ROUND TEXT

The round hand is, like the earlier forms of italic writing, an elegant but extremely practical hand, well adapted to the natural movement of hand and pen. This cursive sample shows the linking of letters through the flowing motion of the pen along the writing line, facilitated by the slanting of the letters. The body height of the letters is equal to the length of the ascenders, and a subtle balance is created by the extended drop of the descenders looping below the baseline. The forms are compressed but the rounded bowls and arches maintain the even texture of the script in the relationship between height and width of the letters. This evenness is also due to the consistency of the pen strokes, in which the minimal variation of pressure and density is fluidly and restrainedly applied.

SQUARE TEXT

Square text is the name given in the original copybook publication to this eighteenth-century calligraphy based on Gothic forms. It is an appropriate designation: although the letters are angularized by the pointed terminals and loženge-shaped serifs borrowed from Black Letter styles, these are grafted onto an adaptation of rounded letters which gives the script a broad, squared quality and medium-weight texture identifiably of its own period, though influenced by the historical source. In the capital letters, the extended, looping hairlines enhance the lively character of the text. Certain authentic medieval letterforms show this type of hairline embellishment, but in this case again, the manner of execution seems to owe more to contemporary fashion than to the origin of the device. But the overall structure of the capital letters and the divided counters of **C, G, O, Q** and **T** have a convincing period flavor.

ROUND HAND

This round hand sample has all the marks of the standard form in its evenly spaced and weighted letters, deliberate proportions and controlled execution. The purpose of copybooks was to distribute widely both the forms of letters considered of particular excellence and functional value and styles of decorative lettering designed to demonstrate the writing master's skills and tax the discipline of the pupil. Round hand was a ubiquitous style of the eighteenth century used as a model script until the early twentieth century and taught in schools as the standard of elegant writing. It is indisputably a formal, attractive hand, though recent fashion in calligraphy has tended to reject the finer copperplate styles in favor of edge-pen letters derived from earlier sources.

REVISED HUMANISTIC SCRIPTS

These two samples draw upon the characteristics of Renaissance hands to develop script letters of sharp angularity matched by more generous, flowing capitals. The first is an inventive, eclectic script; the pairing of capital and small letters suggests that it is developed within its own terms of reference rather than strictly based on a known traditional style. The cursive script originally designated the "secretary" hand, which forms the second sample, is a very tightly constructed, logical and balanced form which, as the name suggests, was intended to be highly functional in day-to-day tasks requiring writing that was rapid but refined, consistent and legible.

FLOURISHED SCRIPT LETTERS

Despite the rococo ornamentation typically applied to copperplate styles, this alphabet has a curiously spare and simple character. The letters are grouped in rows according to the basic body height or presence of an ascender or descender. Within each row the stylization is systematically applied, the extended rightward-leaning ascenders finished by a rounded terminal showing heavy pen pressure, the leftward-flowing tails and descenders sharply turned on a backward angle, except in **g**, where the tail is generously looped. A peculiar inconsistency occurs in the final grouping of letters, which, compared to the rest, are more broadly formed and developed as if to pose an alternative to the original style. A written heading shows, however, that applied as a script this lettering does have an unexpectedly convincing appearance and consistency.

The curved tops of these simple characters are reminiscent of the looped tops used by Cresci in the sixteenth century.

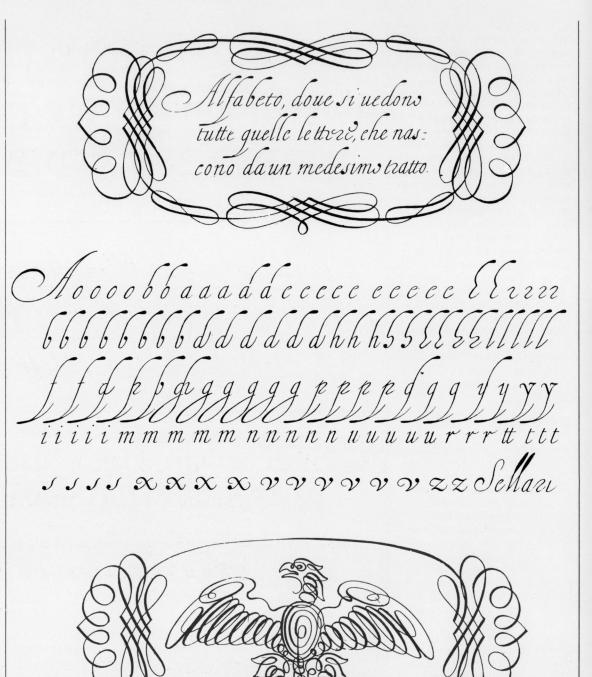

FLOURISHED CAPITALS

These finely developed scrolled capitals demonstrate the versatility of copperplate style. The thick/thin contrast betrays their origin as edged-pen rather than pointed pen letters, though the narrow nib width creates a fluid and lightweight appearance. The construction of each letter is carefully controlled by the evenly spaced writing lines governing body height and internal features. The extended, looping flourishes at the heads and bases of the letter are systematically fitted to these guidelines. The calligrapher, French writing master Charles Paillasson (fl 1760), has allowed himself a final extravagant gesture in the billowing flourished tails wrapped under and around the letters on the bottom line of the alphabet.

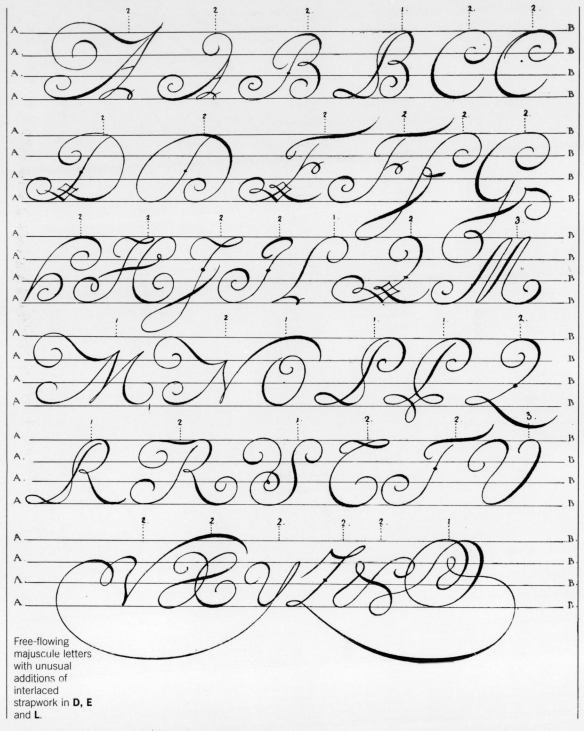

Free-flowing majuscule letters with unusual additions of interlaced strapwork in **D, E** and **L**.

FLOURISHED CAPITALS
The proportions of these letters depart completely from the influence of standard traditional or classical forms. The proliferation of styles that occurred with the widespread publication of copybooks led to much inventiveness in the design of letters, with greater and lesser degrees of success. In this sample of looped capitals there is a consistency in the relationships of the rounded letters, but **A**, **H**, **M**, **N** and **R** are noticeably compressed, while **X**, **Y** and **Z** are converted to comparatively broad forms. Each letter appears to be developed in terms of its own structure, with less regard to the relationships between forms, especially in such details as the double curve of **Q** and the scrolled elaboration of **X**. However, the key to the variations may lie in the fact that the alphabet, with its surrounding ornamentation, is conceived in terms of the overall design effect and each grouping of letters has a definite internal coherence, as does the writer's signature in the central panel, which shows the functional properties of the lettering.

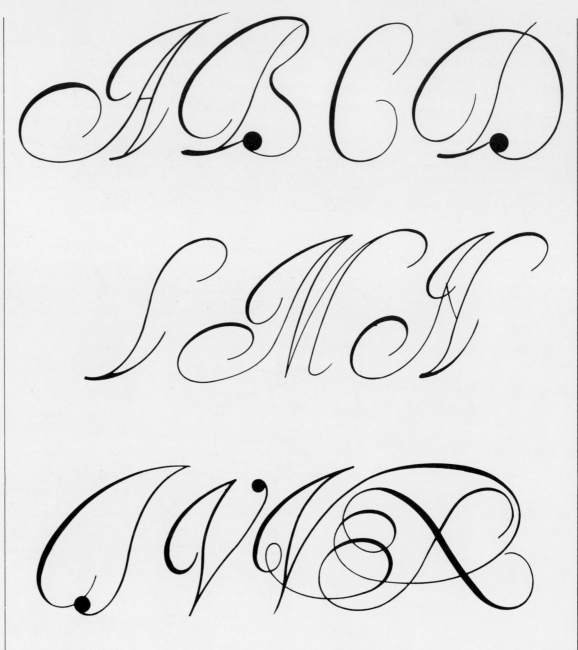

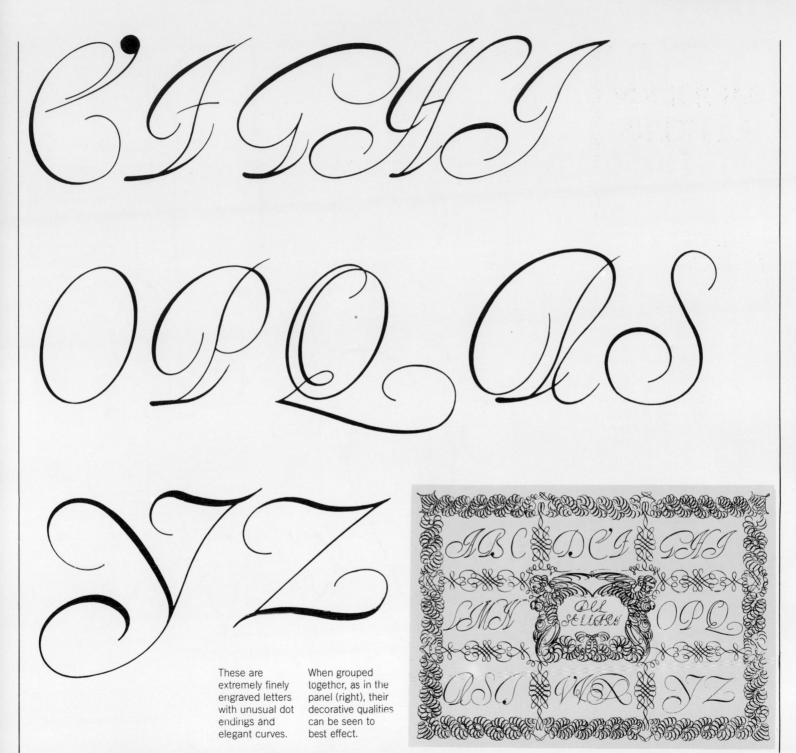

These are extremely finely engraved letters with unusual dot endings and elegant curves.

When grouped together, as in the panel (right), their decorative qualities can be seen to best effect.

MODERN LETTERS

FINE CAPITALS

Modern calligraphy, while repeatedly based on traditional lettering styles, at its best offers a reworking of such forms with a distinctive flavor of its own time. These elegantly refined capitals, based on the classical Roman model, are written with a fine pen that creates a very subtle modulation of width in the strokes. The basic proportions of the letters are seen almost as they appear in the skeleton form, but the fineness of the line is the more appreciable for the delicate contrasts and fluid variation along the width. The alphabet has a deceptive simplicity: accuracy in the relationships between letterforms is carefully preserved, yet there is a vitality to the design which does not overwhelm the sensitivity of the rendering.

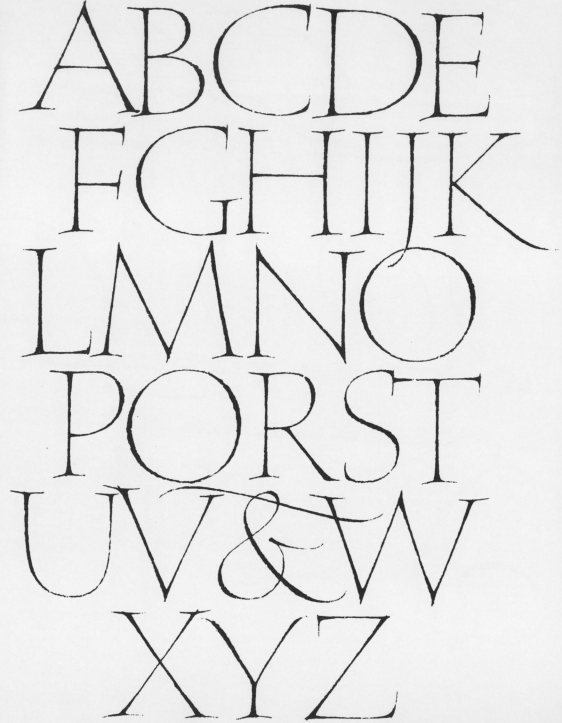

MODERN GOTHIC

The vertical stresses and richly angular patterning of Gothic letterforms have a continuing fascination for the calligrapher in formal terms. This modern reworking emphasizes the narrowed structures and textural density of the letters, written with heavy, vigorous strokes. The overall design has a symmetrical balance, but the lively execution of the letters insures that there is no rigidity in the format. The spidery, light-colored script written through these dense and ordered forms creates an emphatic and effective contrast, so that the piece as a whole demonstrates the successful combination of form and function that is the essence of calligraphic skill.

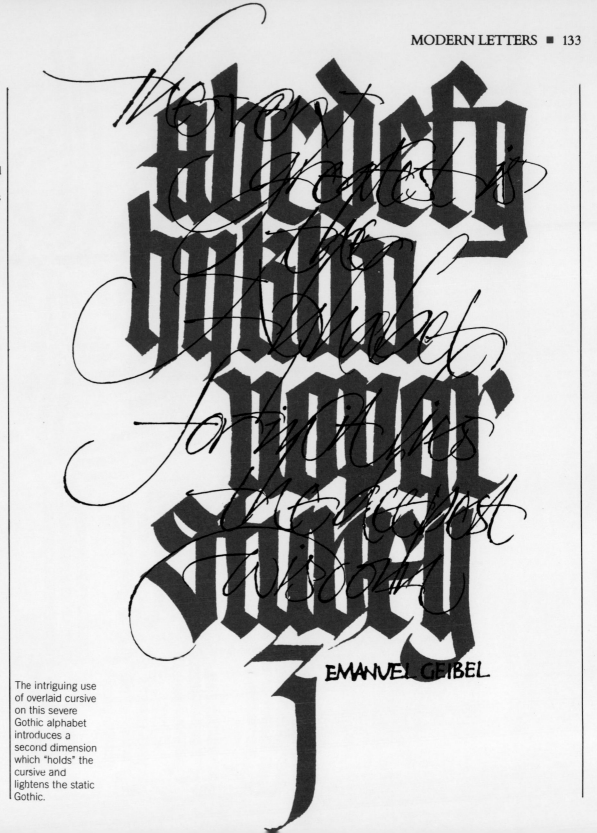

The intriguing use of overlaid cursive on this severe Gothic alphabet introduces a second dimension which "holds" the cursive and lightens the static Gothic.

EMANVEL GEIBEL

TRIPLE-STROKE ALPHABET
The aesthetic qualities of a well-crafted work are always reliant not only on the skill of execution but also on the inherent capabilities of the materials and equipment used in its making. The modern calligrapher has a wide range of traditional and recently developed materials to choose from, any of which may suit particular intentions or suggest alternative elements in the design. Multiple-stroke pens naturally endow lettering with a heavily patterned and even character. The ribbon-like quality of this triple-stroke writing is effectively applied to a simple lower-case alphabet form. Neatly executed turns of the pen create a flowing, scrolled effect of rich texture.

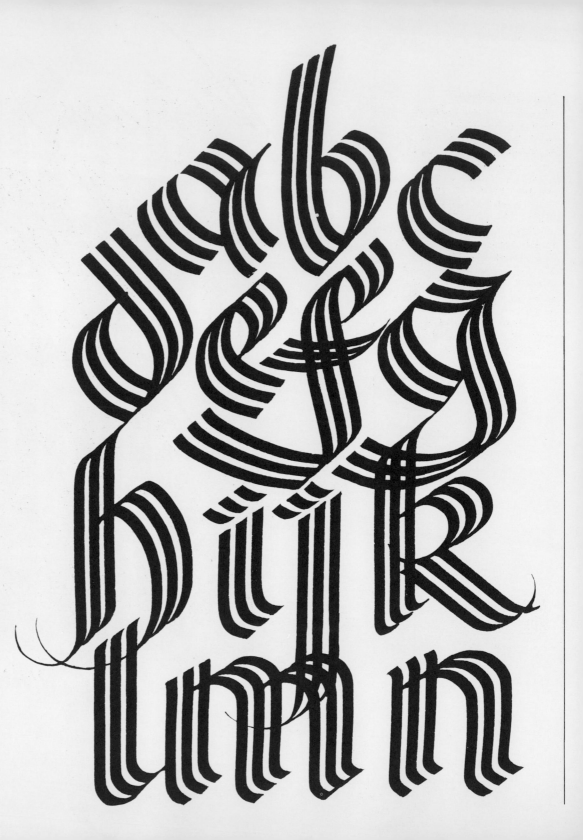

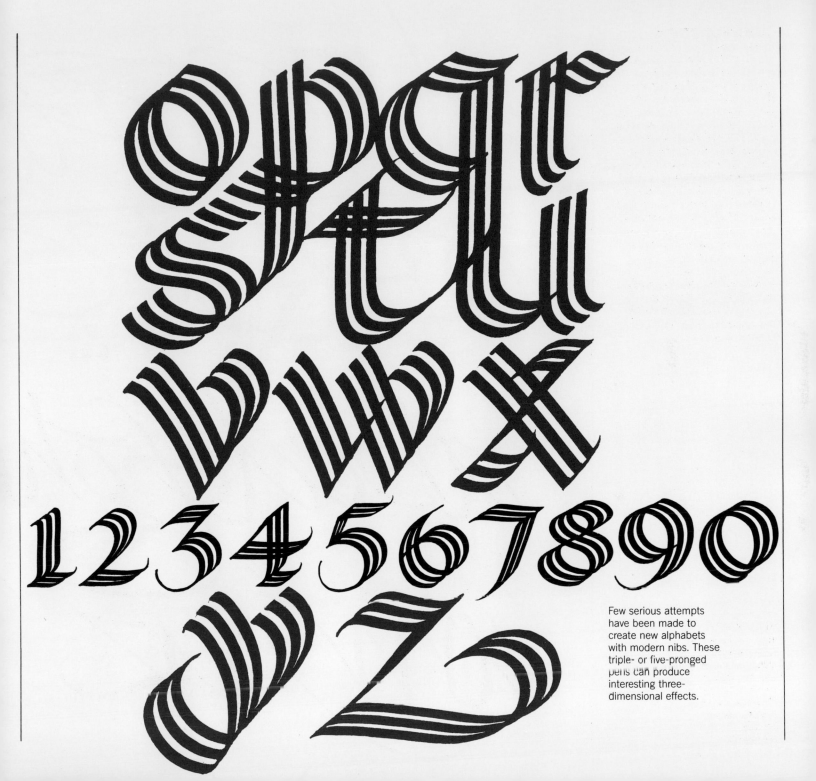

Few serious attempts have been made to create new alphabets with modern nibs. These triple- or five-pronged pens can produce interesting three-dimensional effects.

CURSIVE LETTERING

In some cases the specific character of an alphabet demands absolute consistency in the weight and texture of the strokes, but in this case the textural variations actually caused by the flow of ink lend additional vitality to the traveling lines. There are elements of italic script in the slanted, branching arches of the lower-case letters, but this is an informal interpretation which also exploits the contrast between rounded and compressed forms. The basically horizontal emphasis draws the eye across the writing line. However, there is movement in all directions, suggesting rapid and spontaneous execution. The alphabet combines the calligrapher's appreciation of lettering construction with the functional fluidity of ordinary handwriting.

These alphabets have the lively informality of most cursive alphabets with less contrast in weight of line. Written at speed, it requires almost intuitive judgment.

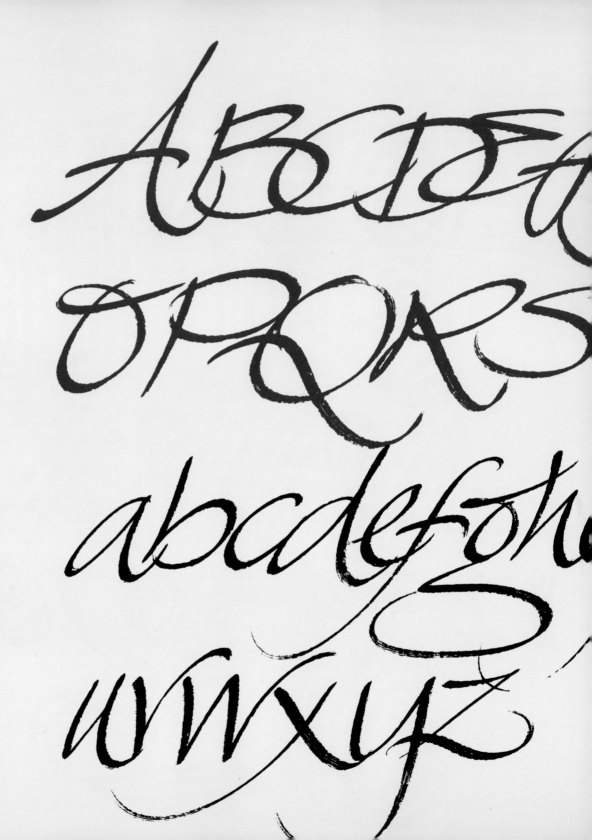

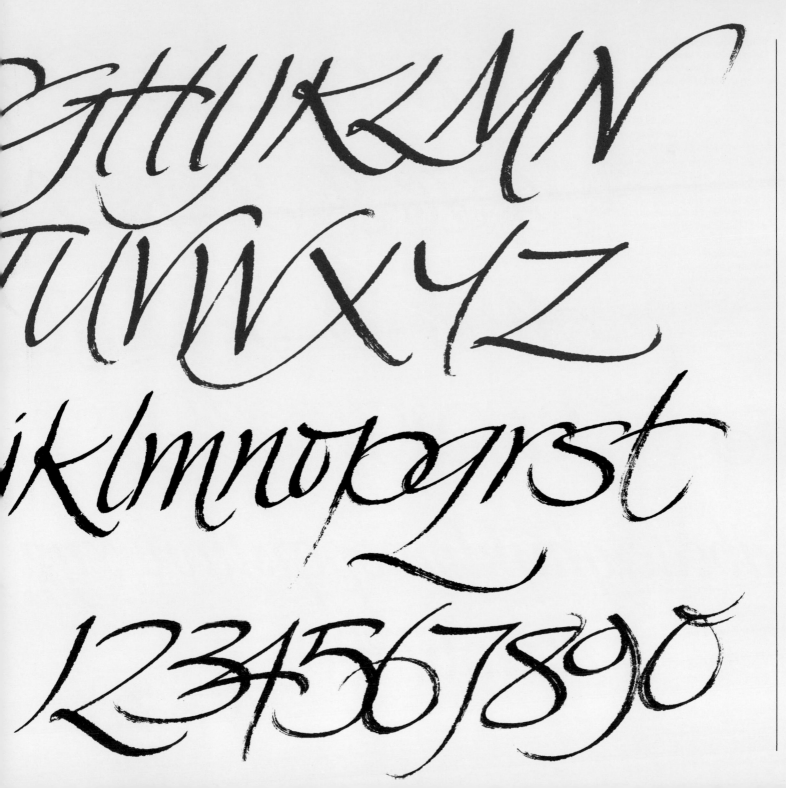

SCRIPT ALPHABET

The continuing function of calligraphy in modern design work is demonstrated by this script alphabet. Designer Richard Bird constructed it specially for use in lettering on wine labels. His requirements were for a traditional letterform with the quality of a script, but closely set and joined and with heavy emphasis on the body of the letters. Existing examples of copperplate scripts and the typefaces based on them appeared too widely spread and spidery in character, so he designed this full alphabet – capitals, lower-case and numerals – to his own specifications. The capitals are weighted in the body of the letter by broad but fluid strokes. The finer flourishes provide appropriate and unexaggerated ornament. The joined lower-case letters are somewhat compressed and have a cursive quality.

A B C D E F

G H I J K L

M N O P Q R

S T U V W X Y Z

Numerals and punctuation marks are carefully worked out, in line with the distinctive features of the script.

abcdefghijklmnopqrstuvwxyz

1234567890

~ & ; :: %?!

FLOURISHED CAPITALS

The rolling rhythms of copperplate writing are here updated in a spiky but fluid capital letter alphabet in which the letters are elegantly interwoven. The forms are not strictly consistent – **E** and **S**, for example, are enlarged, and the **Y** is presented almost as a lower-case form, to terminate the design with an extravagantly looping flourish. However, modifications to the letters are logically contrived to fit the pattern of the overall construction. The flowing movement of the pen is particularly seen in the way the outer stroke of **N** rolls over into the curve of **O**. Lettering design of this type is a well-judged balance between spontaneity and control, and the pattern of the alphabet, though finely textured, is compactly displayed.

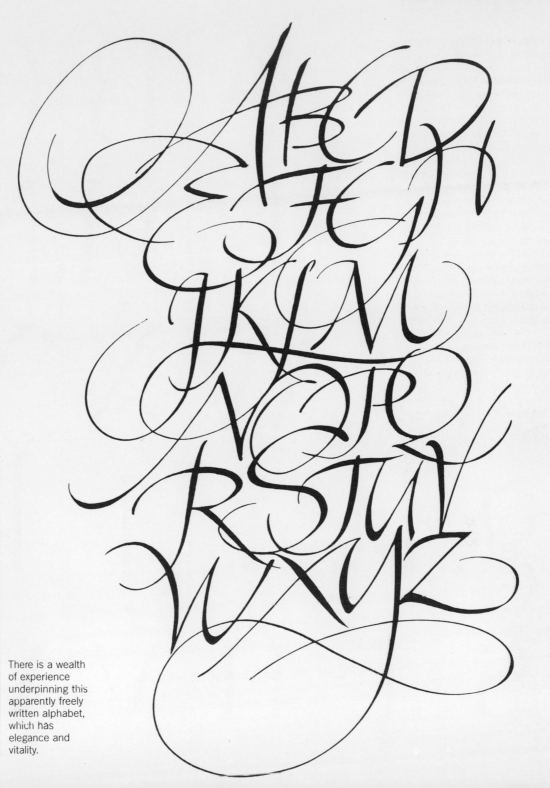

There is a wealth of experience underpinning this apparently freely written alphabet, which has elegance and vitality.

FINE PEN-DRAWN LETTERS

This alphabet form, presented in upper and lower case, has an elegance similar to that of classical Roman models. However, there are a number of refinements in the design which provide a distinctive quality of modernity. Unlike Roman square capitals, which take their proportions from the circular **O**, the rounded letters here are constructed of very shallow curves which compact the outline shapes. Another notable difference lies in the serifs, which cut across the main stroke in classical forms but here lead in only from the left, adding a subtly minimal horizontal stress to the upright lettering. Not only is there the natural variation between thick and thin pen strokes traveling in different directions; the width of line is delicately graduated within a single stroke, creating a slight flaring of the vertical stems and slanted strokes, as well as the fluid swelling on the curves. The capitals and lower-case letters are perfectly matched in style and proportion.

A B C D

L M N O

W X Y Z

g h i j k l

s t u v w x

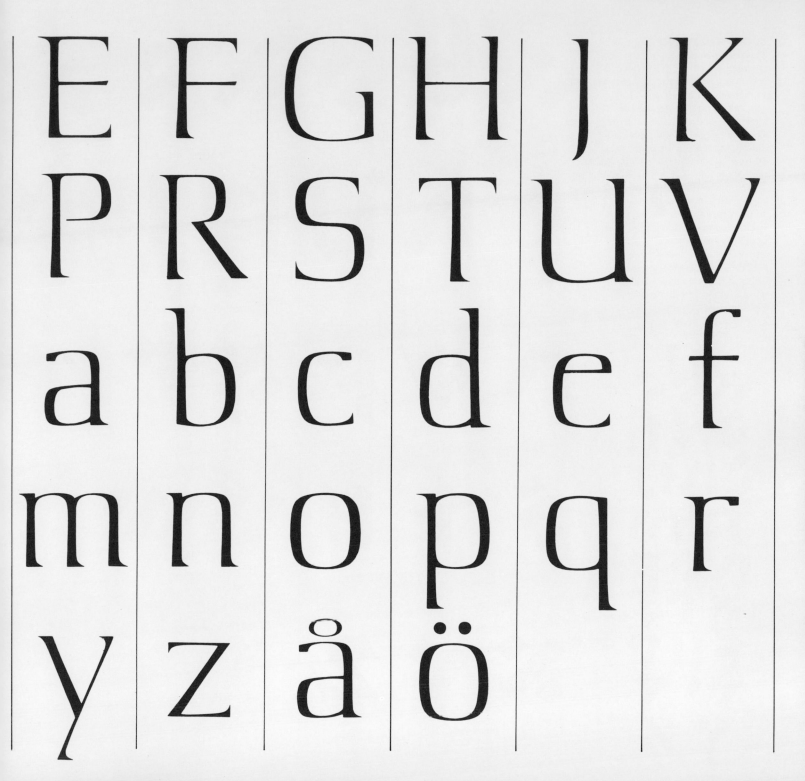

BROKEN LETTERS

This unique and engaging alphabet is constructed from the simplest vertical and slanted strokes made by a square-tipped pen held at an almost constant writing angle. It is an intriguing study of the most basic elements, allowing recognition of the individual letterform: for example, **c** is reduced to two slanted marks, **s** to three parallel strokes. The complete elimination of curves and joining strokes means that almost every form is broken into separate components, yet the familiarity and sequence of the letterforms allows the viewer to read the shapes correctly. However elaborate or elementary an alphabet design, a basic condition of legibility rests in each letter retaining certain essential to the other forms.

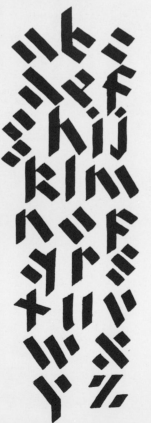

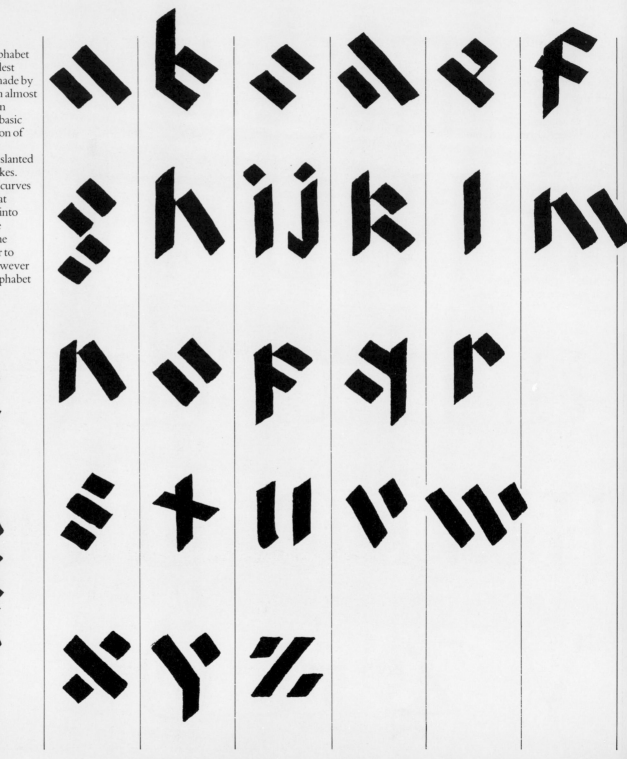

SOLID SQUARED CAPITALS

Although similar in form to the capitals in the sample on page 140, this alphabet has a solid construction and dense textural weight derived from clothing the skeleton shapes of the letters with much heavier strokes, varied in thickness but lacking any highly contrasting modulations of width. The clarity of the letterforms in both samples suggests an equally keen appreciation of both calligraphic writing and typographic lettering. The patterning of straight lines and flattened curves is even and balanced. Individual letters are absolutely distinct in form and consistently proportioned, factors that make an important contribution to legibility.

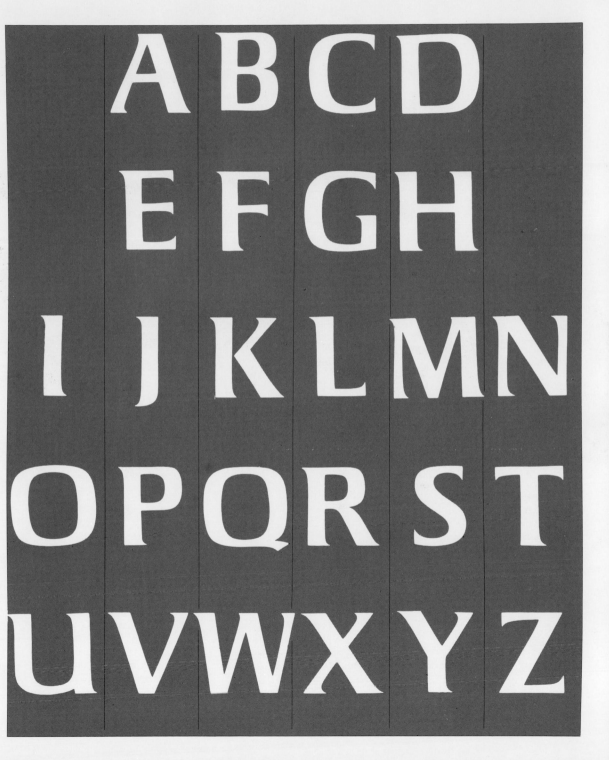

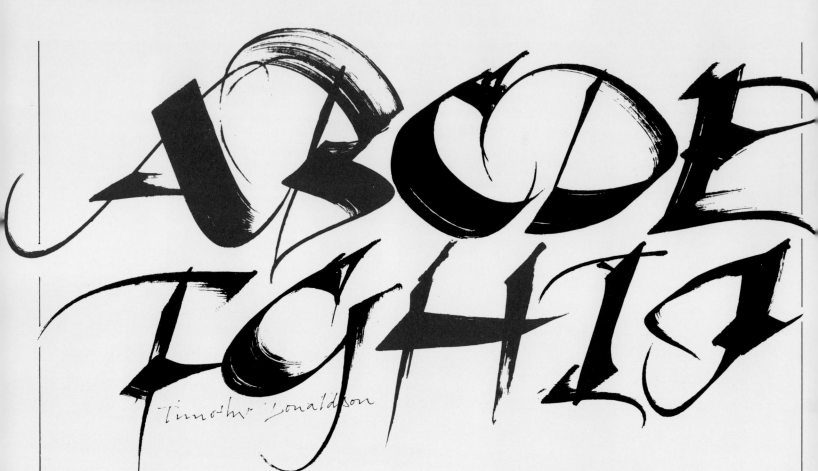

Timothy Donaldson

MODULATED CAPITALS

An extremely broad felt-tipped pen gives a naturally exaggerated variation of strokes and a lively texture created by the contrast between solid black and partially broken marks. Felt-tip pens specially designed for calligraphy offer great freedom and vivacity in the construction of the letters: the loops, angles and slanted strokes are direct and uninhibited. Twists of the pen at the end of the strokes, as in the cross-strokes of **E**, **F** and **H**, add to the ragged, pointed quality. Unlike the well-regulated construction of more traditional alphabet styles, these letters owe their shapes to the speed and looseness of the pen's movement and any repeated rendering of these forms must accommodate the fact that the textural changes are of a more or less random nature.

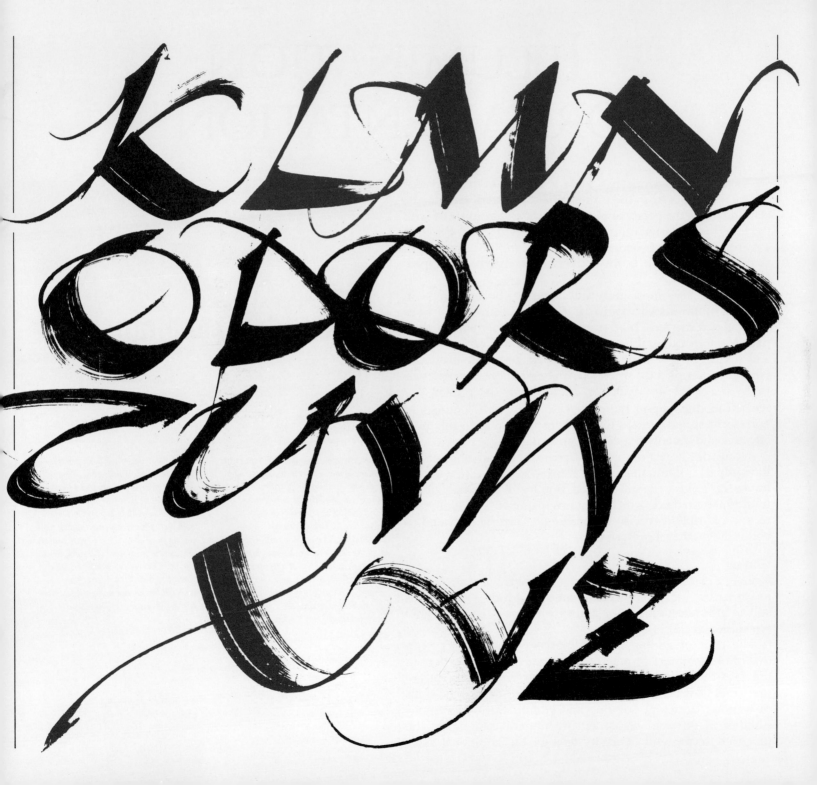

ILLUMINATION & ORNAMENTATION

The decorated letter has been a feature of handwritten manuscripts from the earliest times. A letterform may be elaborated for the personal pleasure of the calligrapher or with the function of designating an important feature of the text, as a complement to a broader style of illustration or as a way of setting off the simple beauty of perfectly written calligraphic forms.

Some of the most beautiful lettering decoration – in medieval illuminated manuscripts – was created by scribes using the restricted color palette available to them in their day. Modern calligraphers have access to a wealth of color and texture in the current range of art and craft products. However complex the intended ornamentation, the materials to do the work are available. In addition, the present-day scribe can draw upon the design experience of centuries in both written and printed texts for inspiration as to the most effective and inventive means of presentation.

In only one aspect of the craft have technical advances made little impact: gilding in its finest form – the application of thin leaves of gold – is still carried out by a long-established traditional method which requires patience and skill. No recent attempts to revise the technique have been found to better the medieval prescription.

Gilding

Gold is a mark of special value in a handwritten text; as with its earlier use for the embellishment of religious writings, it is still an indication of the care and expense invested in a highly wrought piece of calligraphy.

The craft of gilding has traditionally been distinct from that of fine writing, despite their long and close association. In the days of the scriptoria – the monastic workshops for the preparation of handwritten and illuminated texts – the skills of writing, drawing, coloring and gilding were the responsibilities of different craftsmen. In modern calligraphy, the practiced scribe will generally acquire the additional skills

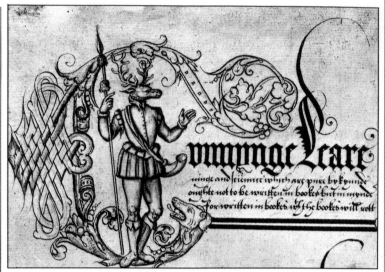

Elaborately ornamented initial letters are a feature of many old manuscripts and copybooks. As this English sample (above) dating from 1600 shows, pen-drawn decoration has a richness of its own comparable to that of painted illumination. The woven scrolling to the left of the design is a traditional form of ornament, as is the use of a figure standing inside the shape of the letter. The lines of formal Gothic and cursive calligraphy are finely balanced against the ornamentation.

The form of decorated book described as a Book of Hours, a collection of prayers and texts for private use, produced some of the best examples of manuscript illumination, ornamented with glowing colors and gold leaf. This is a Netherlandish work dating from about 1475 (right), containing a beautiful miniature of the Flight into Egypt. The color scheme is carefully controlled, using the richest colors available at the time and a combination of flat and raised gold decoration.

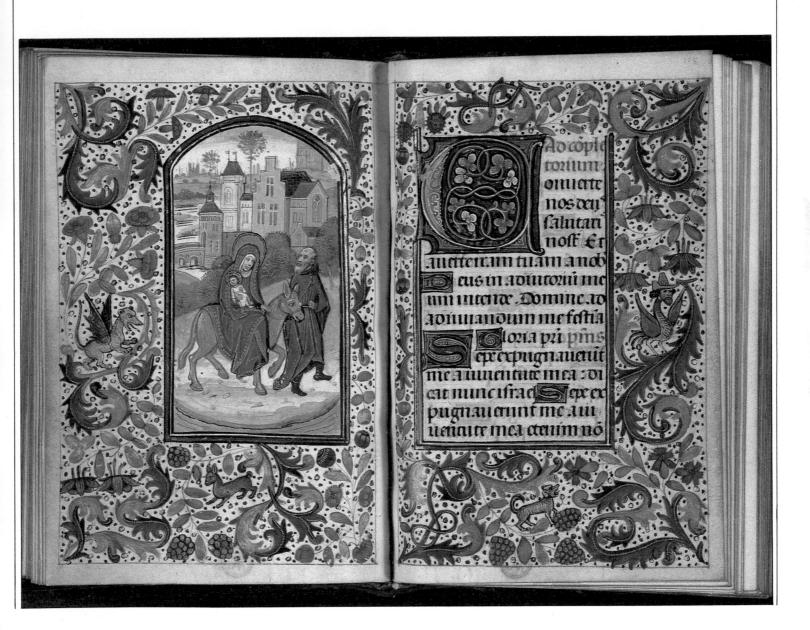

of decoration as they become necessary to the work. The working process is as before, even when carried out by one person: the text is fully written out, leaving space for the gilded forms or colored decoration. The ornamentation is then drawn in and the colors and gold are applied in separate stages toward the completion of the whole work.

There are two different methods of applying gilded decoration, each having a distinct character and form in the design. Gold can be painted or written into a single letter-form or ornament, or flooded into the background of an ornamental panel, using powder gold bound in gum.

Powder gold is usually available in the form of dry cakes, already mixed with the gum binder. It is used directly by moistening the cake with a wet brush to liquefy the gold and is transferred to the writing surface by charging a brush or quill with gold. This method is suitable only for flat decoration and is convenient as a filler for pen-drawn ornamentation, if delicately applied with a fine brush or pen. It can be burnished when completely dry, but does not achieve a high shine.

The richest method of gilding consists of laying thin sheets of gold on the page to adhere to a flat ground of glue size previously laid on the surface, or to a raised cushion of gesso, a fine plaster-like substance made to a special recipe for use in gilding.

Gold leaf is pure gold beaten out into very thin, flexible sheets. When laid on a flat or raised surface by means of an adhesive ground, it must be burnished lightly to set it in place; as it dries out completely, it can be burnished again to bring up the brilliance of the gold in a lustrous effect which is very long-lasting. Raised gold decoration laid onto a thick layer of gesso is particularly effective because the relief surface catches the light all the more variously, giving rich reflection from the burnished metal.

If the gesso is correctly prepared, it is solid but slightly flexible and therefore suitable for use on a heavy paper or vellum base, since it will not crack when the page is turned or flexed. A light moistening of the gesso is what causes the gold to adhere; subsequent work with a burnisher perfects the gilded shape, and the loose or ragged edges of gold leaf which have not adhered are cleanly brushed away.

Silver, bronze and platinum are also available in leaf form, and though the term "gilding" accurately refers to the use of gold, the technique covers decoration with other metals. The leaves, supplied in small books, are relatively expensive, but in calligraphy precious metals are rarely used in large

Illumination is traditionally associated with gilding in pure gold leaf, and this modern sample of a motif developed from runic characters (above) employs burnished silver and gold leaf. The raised strokes are formed in gesso and the flat forms are in gum ammoniac. Gold and silver are also the highlights of a quotation from a poem by J.R.R. Tolkien (right). The raised, gilded letters contrast with the vivid red gouache of the quill pen script. The heavily textured background comes from a mixture of colored drawing inks.

INFLUENCE
CREATES
NOTHING

IT AWAKENS

André Gide

*The simplicity of this sample (above)
imbues it with a grandeur that belies its
delicate proportions. The script is written
with a quill and gum ammoniac forms a
base for the gold leaf. An effective
combination (right) of several motifs in
silver and gold leaf on gum ammoniac,
and gouache, written with a quill.*

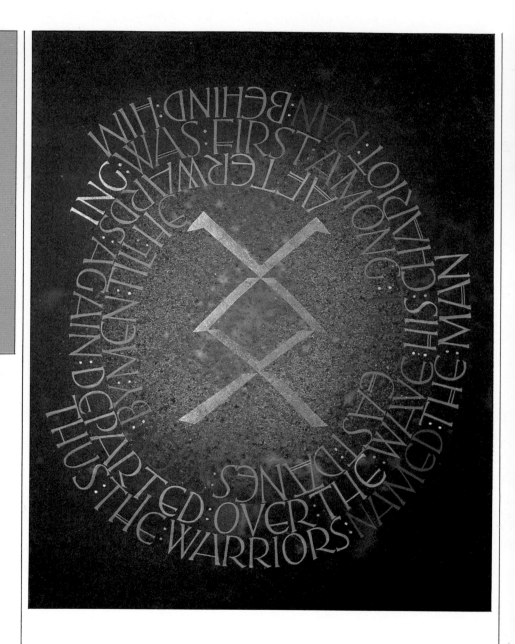

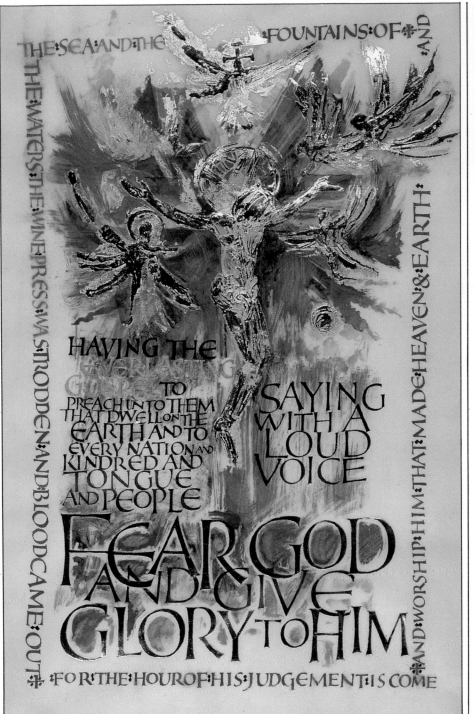

Two contemporary examples of gilding illustrate the mastery of the art demonstrated by one of today's most accomplished craftsmen. The coat of arms (above) of the Leathersellers' Company is a detail taken from a Freedom certificate for Sir Ronald Gardner Thorpe, GBE, TD, DCL. Written with a goose quill on calfskin vellum, the gold and platinum leaf are applied to a gesso base. The entire piece is only 10 × 9 cm (4 × 3½ in). A modern interpretation of a passage from the Book of Revelations (left) is in gold leaf on gesso–based calfskin vellum. Powder gold, stick ink and azunte with gouache pigments have also been incorporated.

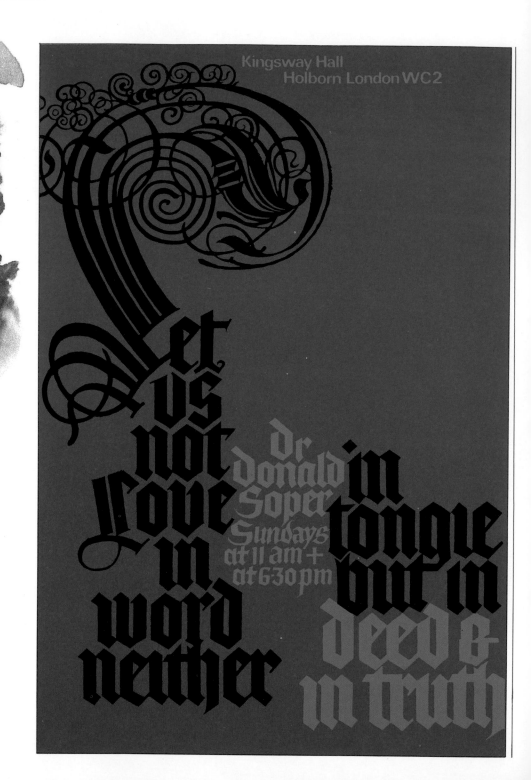

Various resist methods are used by modern calligraphers to create an effect of white lettering reversed out of a colored background. Liquid masking fluid can be used to write finely, as in this elegant italic sample (above). A loose, cloudy effect of color is achieved by flooding the text with ink. Stark tonal contrasts and the bold forms of Black Letter create a memorable poster image (right) in flat color. Each element in the work has a strong presence contributing to the overall style. The change of tone between light and dark letters on a vibrant red ground emphasizes the graphic qualities.

And there the snake throws her enamell'd skin weed wide enough to wrap a fairy in

Kingsway Hall
Holborn London WC2

Let us not Love in word neither

Dr Donald Soper
Sundays at 11 am + at 6.30 pm

in tongue but in deed & in truth

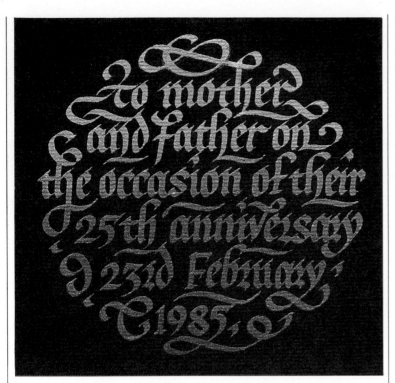

A formal piece of calligraphy marking an anniversary (above) consists of silver leaf laid over gum ammoniac on black Ingres paper. The application of translucent inks airbrushed over the lettering gives a subtle effect of graduated color metallic.

An area of graded textured color is airbrushed into a mask to follow a strictly geometric format (below), the background for the exuberantly sweeping calligraphy extending across the shape. The use of closely toned colors maintains cohesion in the design.

amounts. The calligrapher/gilder will soon be able to judge how to cut, lift and lay an amount of gold leaf that economically covers the form being gilded. For rough work and preliminary designs, metallic inks are useful and adequate, but none of the liquid preparations or metallic paints simulate the true brilliance of burnished gold leaf.

Colors

Simple color decoration of handwritten texts goes back to early Egyptian writings, and a long-standing tradition has been the use of red pigment to contrast certain characters or features of a text against the general distribution of a black or warmly tinged, dark ink. As with the development of painting, calligraphic decoration has at all times depended largely on the availability of materials: the use of vermilion or ultramarine at one time implied a particular value in a way similar to that of gilding, because these were scarce and expensive pigments, carefully conserved and sparingly applied.

A deliberately restricted color scheme can often prove highly effective if the colors are sensitively selected. But fortunately there is now no reason for economics or availability to limit the calligrapher's approach to designing with color. Variations in the cost and quality of modern pigments are relatively minor. Calligraphers can choose from a readily available range of paints and inks offering the full spectrum of color. Those preferring traditional methods can obtain dry pigments and mix true tempera paints – pigment bound in egg yolk. But watercolor paints, available in tubes or pans, provide hues that are both brilliant and transparent; thinned with water, these paints can be brushed on or will pass easily through a metal pen or quill. Drawing inks are also useful, although these may tend to fade, and special fiber-tip pens tailored to calligraphic requirements offer a ready source of vibrant color for direct application.

Versal letters and ornamentation in text and margins are obvious candidates for decoration with color. A fully illuminated manuscript, possibly including the use of gold, can have a richness and variety unsurpassed in this scale of design. The original miniatures in illuminated manuscripts were tiny pictures painted inside the large initial capitals opening a page or paragraph of text. In many cases, these were highly detailed and finished works in their own right. Complex decoration in page margins also included the use of pictorial images, to illustrate the text or depict contemporary scenes appropriate and familiar to the audience for the

writings.

Current methods of applying color correspond to these traditional forms, but also include techniques garnered from other fields of art and design. "Reversed-out" lettering, that is, showing white on a darker ground, can be achieved by various resist methods. For example, the lettering can be written originally with a masking fluid that repels paint when the surface is flooded with color. Or it can be written in white water-soluble paint and then flooded with waterproof inks. When the inks have dried, the surface is washed to lift the paint and reveal the forms of the letters through the ink layers.

Lettering written layer upon layer in transparent, spirit-based inks – as contained in most broad-tipped marker pens – builds up a rich pattern of color while allowing the forms to remain distinguishable. These methods of working with color are often favored because of the random elements contributing to the appearance of the finished work, but there is also an obvious pleasure in executing a highly de-tailed and planned illumination governed by careful prepara-tion of the layout and featured drawings. Color is not necessarily an addition to calligraphy – it can also be the basis of a particular work – and this approach offers pleasing alternatives to the satisfactory sharpness of black lettering on a white background.

Flourishes and linear decoration

Linear decoration is the natural complement to handwritten text, whether it consists of extended pen movements flourishing the terminals of the letter strokes or carefully drawn ornamental motifs designed to surround and mix with the writing lines. While there is a particular appeal in illumination using gold and colors, some of the most beautiful examples of early manuscripts are decorated with pen-drawn ornamentation only, and this can have a richness of texture that belies the simplicity of the technique.

The simplest form of elaboration is a fine hairline flourish extending or terminating a stroke, and this is extremely effective when a rapid twist of the pen turns a thick stroke into a fine hook or loop. The distribution of hairlines throughout an otherwise plain piece of lettering gives it variety and spontaneity – a lively texture that encourages the eye to travel along the design, whether it is a basic alphabet arrangement or regulated lines of text. More elaborate flourishing ranges from exaggerated looping of tails and ascenders to billowing masses of interwoven lines extending into the margins of the page, as

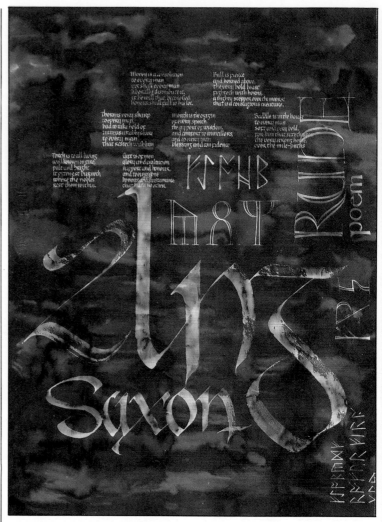

This experimental sheet consists of Anglo-Saxon script, versals and runic letters written into ink wash with a bleach solution which forms the calligraphy in pale tones on the dark ground. The color and texture are not completely controllable by this method, but the random qualities of the texture have a pleasing effect when the letters themselves are sharply defined and evenly constructed. The bleach method is a useful technique, but special care is needed in handling the caustic fluid.

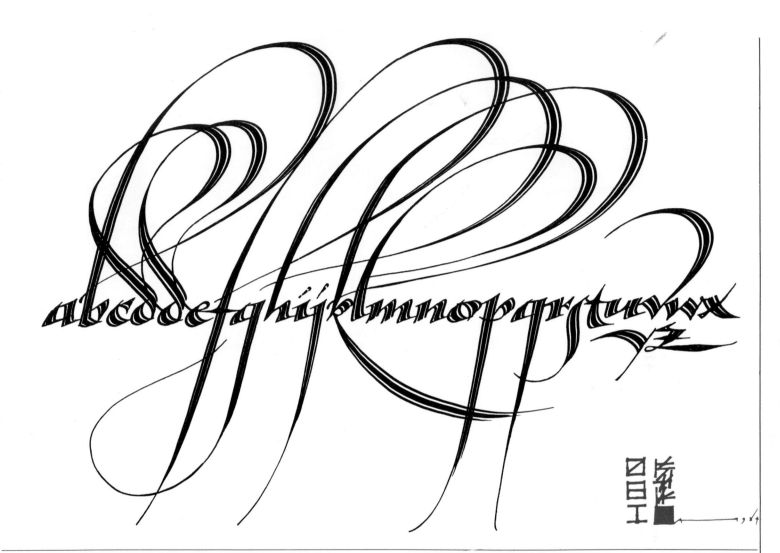

abcddefghijklmnopqrstuvwxyz

Multiple stroke letters automatically acquire an ornamental appearance, and in the case of this simple italic lower-case alphabet (above), the effect is exploited by drawing out the ascenders into fluid, sailing loops. To maintain the evenness and consistency of the stroke pattern, a divided nib is used; these are available in many weights and thicknesses, giving from two to five divisions of the stroke. A more skillful but infinitely more difficult and time-consuming approach is to build up the multiples from single lines.

A historical example of patterned lettering demonstrates the painstaking build-up of even, well-matched single strokes to create the elaboration of the form. For early copybooks the careful work of the penman was echoed by the highly skilled craft of the engraver, and in these decorative capitals it is possible to identify the many separate strokes of the engraver's tool used to recreate the thickness of the pen stroke. The fine, natural line of the graver is visible in the lightweight plant and figure motifs.

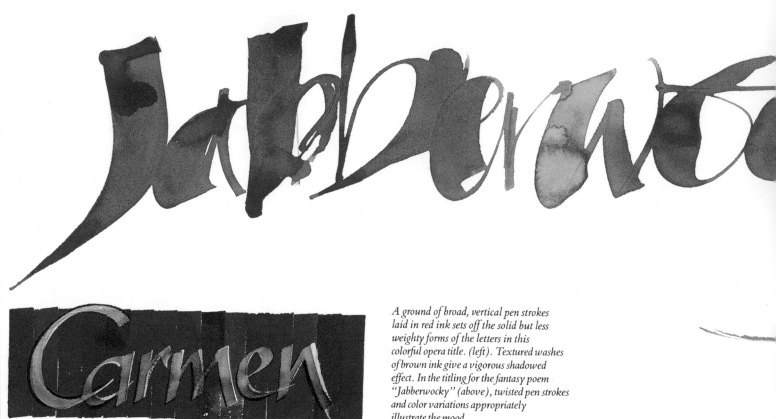

A ground of broad, vertical pen strokes laid in red ink sets off the solid but less weighty forms of the letters in this colorful opera title. (left). Textured washes of brown ink give a vigorous shadowed effect. In the titling for the fantasy poem "Jabberwocky" (above), twisted pen strokes and color variations appropriately illustrate the mood.

was a common feature of copperplate writing samples, which were often heavily bordered with pen loops and curls.

Tone and texture are the key to balanced linear decoration in calligraphy. Black lettering on a page has an overall pattern and weight, depending upon the heavy or open character of the letterforms and the degree of variation in design throughout the whole alphabet. In general, a satisfactory result in the elaboration of pen letters depends upon following through the consistency in the lettering design with regard to weight of stroke, thick/thin contrasts and the basic character of rounded, compressed or angular forms. Texturally, flourishes should balance and complement the overall pattern of the text rather than overwhelm it, and persistent practice with the writing tool is the best way of identifying its decorative possibilities.

However, good design is also partly a matter of intuition, and it is possible to make unexpected juxtapositions of style that function effectively through the fluidity and confidence with which they are executed. Further, the purpose of the exercise has a bearing on its form: it is acceptable to take more liberties with an alphabet design than with a formal text whose prime function is legibility. In designing flourished letters, if the alphabet is to be put to use in the writing of a text, the letters must be considered not only in their own right but also as they will appear when distributed randomly and in varying combinations on a page. More modification of the decorative elements may be needed as this occurs.

Additional decoration in the form of linear ornament can be constructed in abstract terms from this same appreciation of the true character of the letterforms and the tool with which they are written. Traditional forms of margin decoration often employ motifs culled from plants and other organic structures, and variations on vine patterns and similar tracery effects are good companions for fine and medium weight scripts. Heavy lettering, such as Black Letter, requires equally balanced, solid and consistent decoration.

A loosely written alphabet quartered in panels of white on black (right) is enlivened with delicately placed highlights of vivid color. The position of this minimal color detail is varied in each sector to link all parts of the design. Heavy letters based on uncials (below) have an antique character created by allowing the dark ink to spread hazily out into a wash of gray.

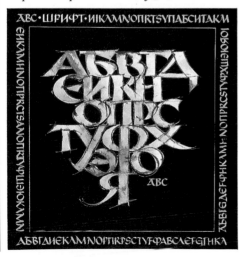

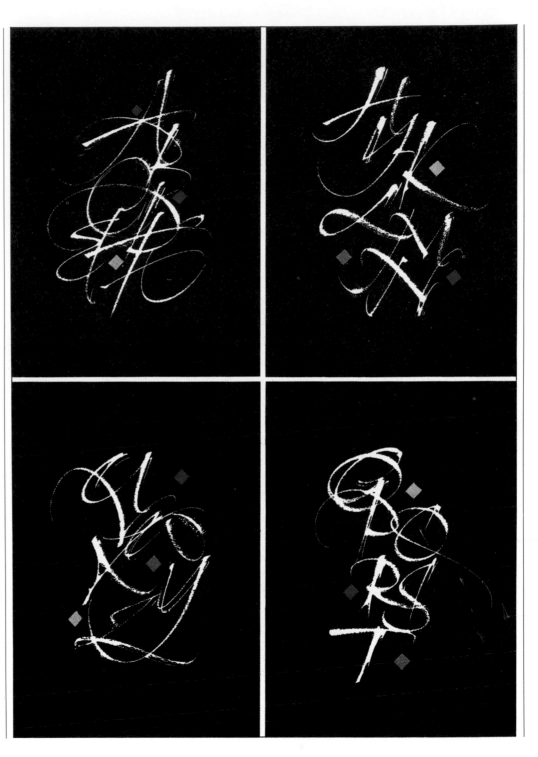

CREDITS

Key: top (t); center (c); below (b); left (l); right (r).

The illustrations and alphabets on these pages were reproduced by courtesy of the following:

7 Ursula Dawson (t, bl); Michael Freeman (br)
10 V & A Museum (l, br); The Board of Trinity College, Dublin (tr)
11 V & A Museum
12-13 V & A Museum
14 Rupert Bassett (l); Timothy Donaldson (c); Peter Thompson (r)
15 Robert Boyajian (l); Timothy Donaldson (r)
16 Peter Thompson
26-27 Miriam Stribley
28-29 Miriam Stribley
30 Miriam Stribley
31 Peter Thompson
32-33 Dover Publications
34-35 Dover Publications
36-37 Werner Schneider
38-39 Pitman Publishing
40 Pitman Publishing
41 Arthur Baker, Dover Publications
42-43 Arthur Baker
44 Miriam Stribley
45 Edward Johnston, V & A Museum
46-47 Dorothy Mahoney, Pelham Books
48-49 Peter Thompson
50-51 Miriam Stribley
52-53 Peter Thompson
54-55 Miriam Stribley
56 Miriam Stribley
57 Evert van Dijk, Gaade Uitgevers
58-59 Miriam Stribley
60 Miriam Stribley
62-63 Dover Publications
64-65 Dover Publications
66-67 Based on Hans Meyer, Graphis
68-69 Miriam Stribley
70-71 Miriam Stribley
72-73 Miriam Stribley
74-75 Dover Publications
76-77 Dover Publications
78-80 Based on Johann Neudorffer, Dover Publications
81 Dover Publications
82 Rudolf Koch, Merrion Press
83 Based on Hans Meyer, Graphis
84-85 Dover Publications
86-87 Miriam Stribley
88-89 Dover Publications

90 Based on Hans Meyer, Dover Publications
91 Arthur Baker, Dover Publications
92-93 Arthur Baker, Dover Publications
94-95 Miriam Stribley
96 Dover Publications
97 Miriam Stribley
98-99 Miriam Stribley
100-01 Miriam Stribley
102-03 Miriam Stribley
104 Peter Thompson
105 Dover Publications
106-07 Werner Schneider
108 V & A Museum
109 Dover Publications
110 V & A Museum
111 Dover Publications
112-13 Arthur Baker, Dover Publications
114 Arthur Baker, Dover Publications
115 Timothy Donaldson
116-17 Hans Meyer; Graphis
118-19 Dover Publications
120-21 Dover Publications
122-23 Dover Publications
124-25 Hans Meyer, Graphis
126-27 Dover Publications
128-29 Dover Publications
130-31 Dover Publications
132-33 Timothy Donaldson
134-35 Miriam Stribley
136-37 Rachael Yallop
138 Richard Bird
139 Robert Boyajian
140-41 Errki Ruuhinen
142 'Manya' by Miriam Stribley
143 Errki Ruuhinen
144-45 Timothy Donaldson
146-47 V & A Museum
150 Peter Thompson
151 Donald Jackson
152 David Bridges (1); Miriam Stribley (r)
153 Peter Thompson (t); Dean Robinson (b)
154 Peter Thompson
155 Arthur Baker (t); Dover Publications (b)
156 Joanna Bennett (t); Christopher Bentley (b)
157 Leonid Pronenko (1); Timothy Donaldson (r)

While every effort has been made to acknowledge all calligraphers and copyright holders, we apologize if any omissions have been made.